KT-567-351

ODILON REDON
EDITED BY
CAROLYN KEAY

Introduction by Thomas Walters

ACADEMY EDITIONS·LONDON

ACKNOWLEDGEMENTS

We would like to thank all the museums, galleries, institutions and private collectors who have generously allowed their works to be reproduced. In particular we are grateful to the British Museum for providing photographs of prints in their collection.

First published in Great Britain in 1977 by
Academy Editions, 7 Holland Street, London W8

Copyright © Academy Editions, 1977 *All rights reserved*

SBN Cloth 85670 240 4 SBN Paper 85670 245 5

Printed and bound in Great Britain by
William Clowes & Sons Ltd., Beccles, Suffolk

60/60223 759.05/R

BK01135

BK01135

ODILON REDON

BK01135

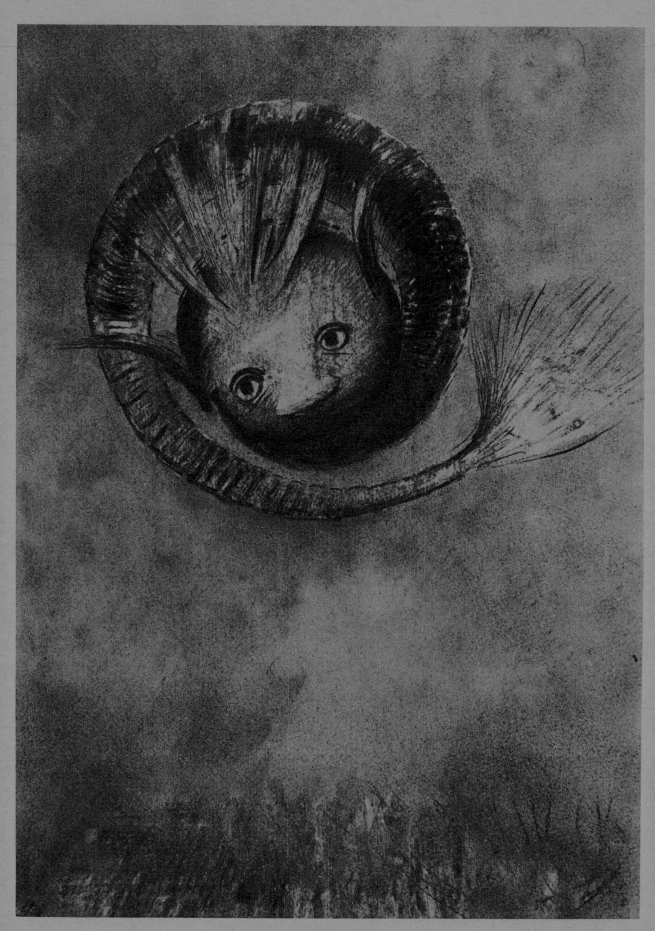

Fantastic monster / *Monstre fantastique* *c* 1880–85
Charcoal 48 × 34 cm
(Rijksmuseum Kröller-Müller, Otterlo)

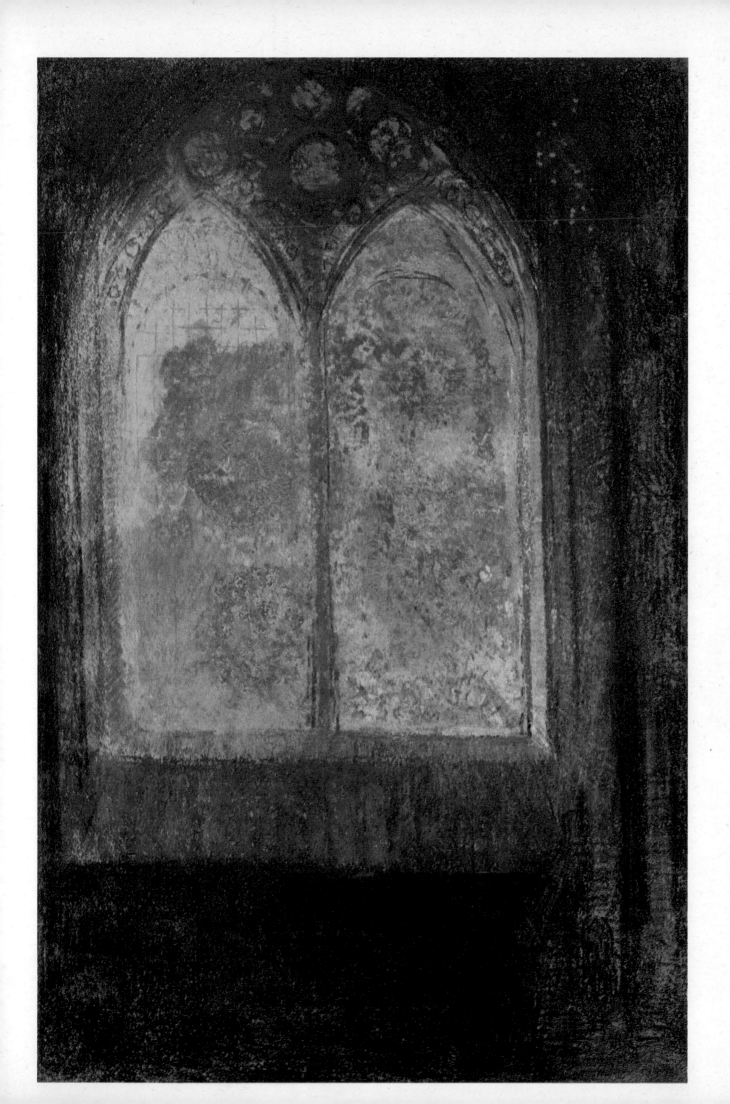

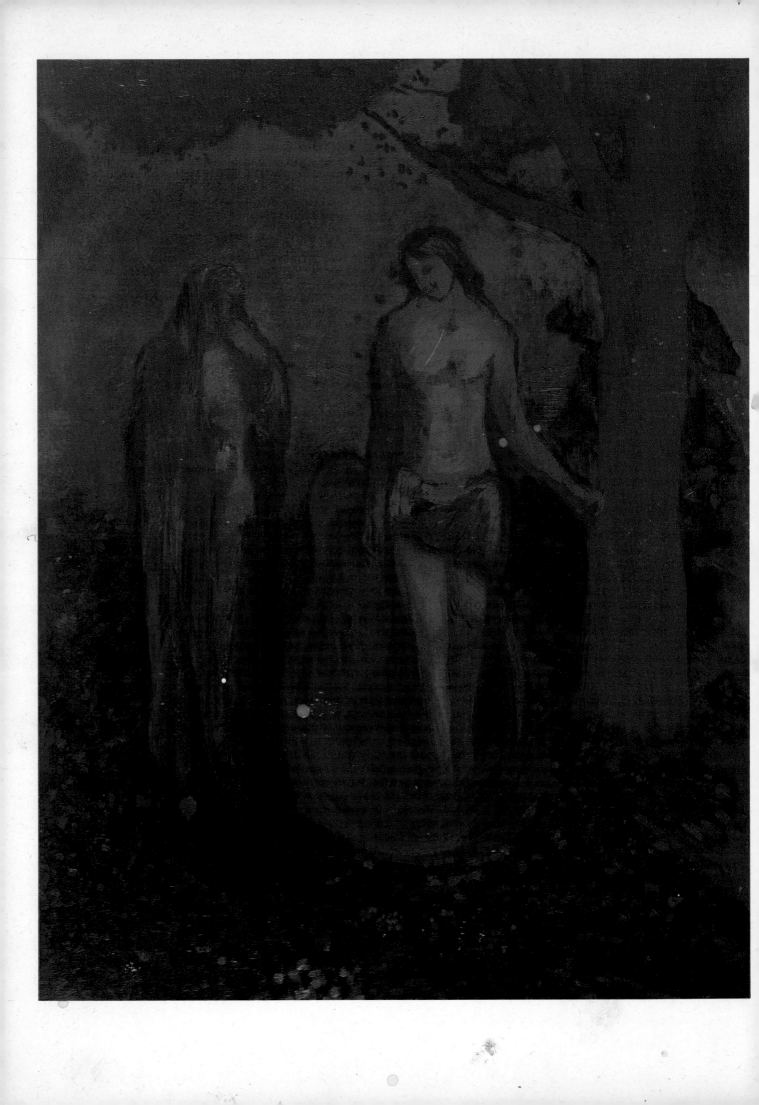

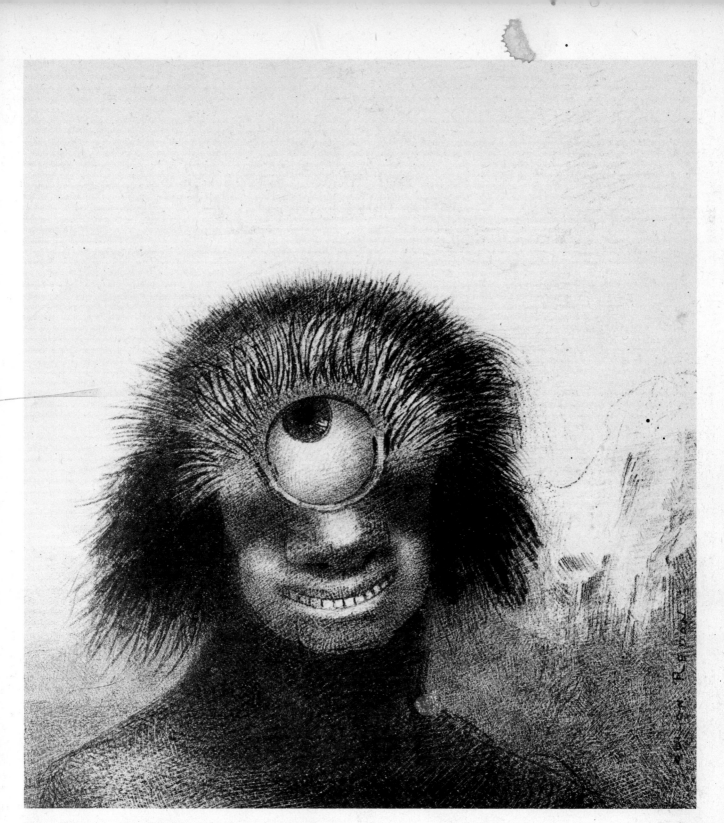

The misshapen polyp floated on the shores, a sort of smiling and hideous Cyclops / *Le polype difforme flottait sur les rivages, sorte de Cyclope souriant et hideux*, No. 3 of *Les Origines* 1883
Lithograph 21.3 × 20 cm

Opposite

Red tree not reddened by the sun / *L'arbre rouge* 1905
Oil on canvas 45.7 × 35.5 cm
(Courtesy of Arthur Tooth & Sons Ltd)

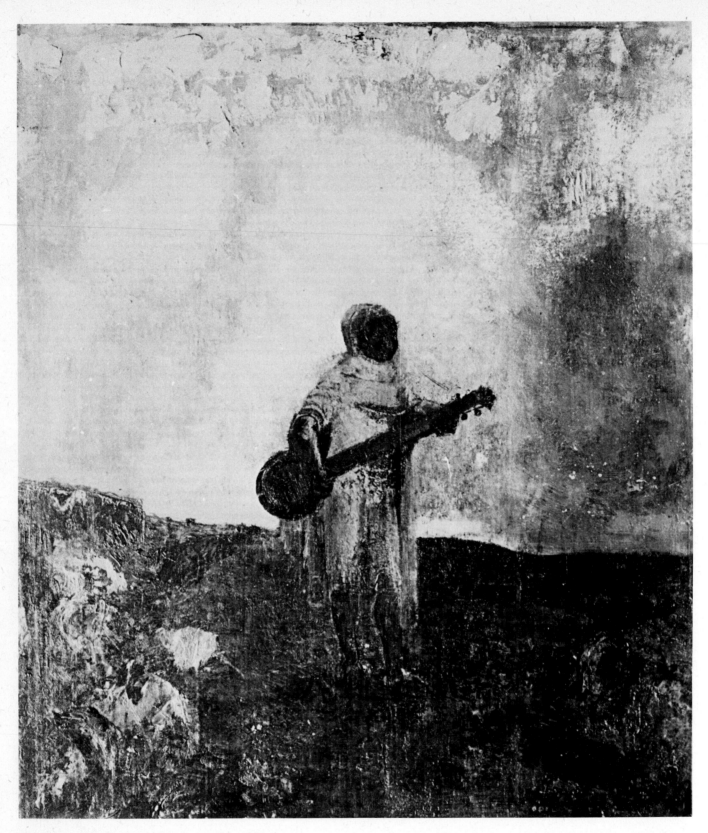

The Arab musician / *Le musicien arabe* 1893
Oil 51 × 44 cm
(Musée du Petit-Palais, Paris)

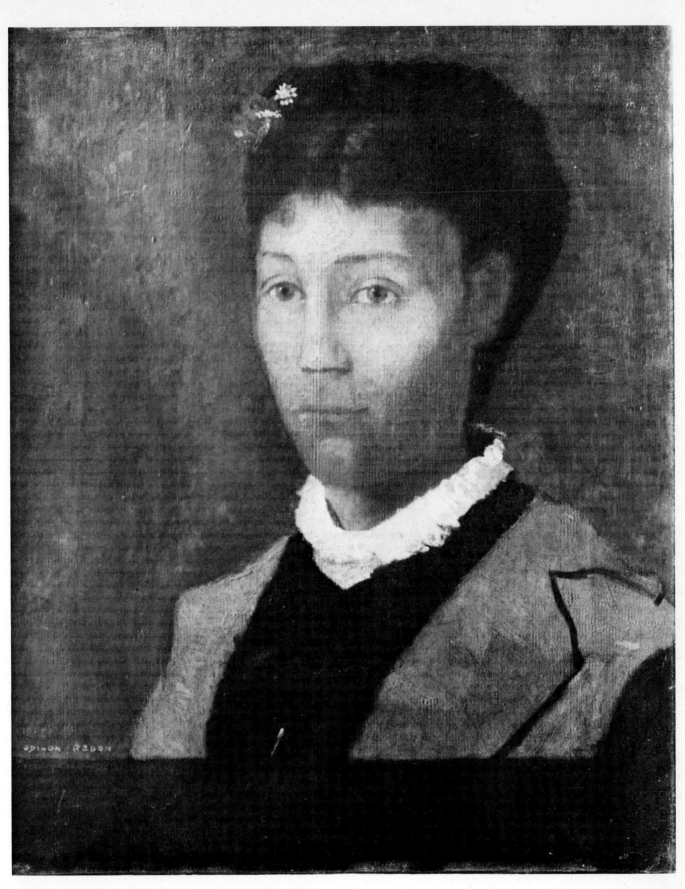

Portrait of Madame Redon / *Portrait de Madame Redon*
1882
Oil 45 × 37 cm
(Musées Nationaux, Paris)

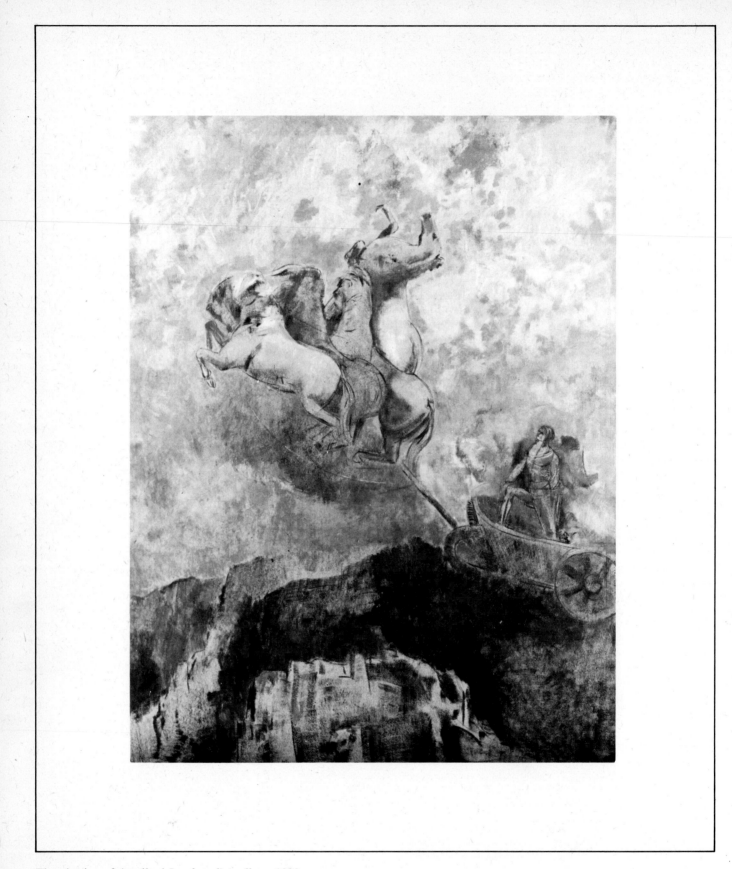

The chariot of Apollo / *Le char d'Apollon* 1909
Oil on board 100 × 80 cm
(Musée des Beaux-Arts, Bordeaux; photo A. Danvers)

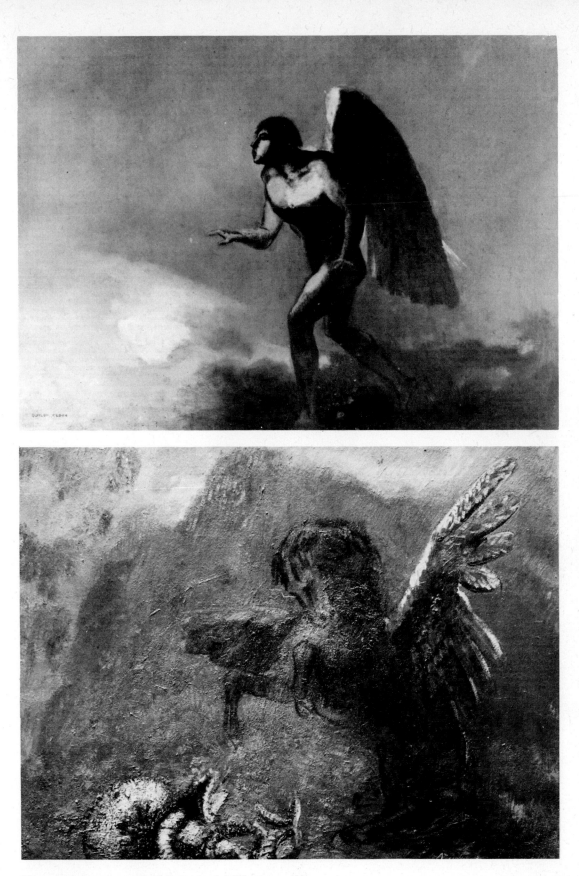

The winged man, or the fallen angel / *L'homme ailé,*
on l'ange déchu c 1890–95
Oil on canvas 24×34 cm
(Musée des Beaux-Arts, Bordeaux; photo A. Danvers)

Pegasus and the dragon / *Pegase et le dragon* c 1905–07
Oil on cardboard 47×63 cm
(Rijksmuseum Kröller-Müller, Otterlo)

15

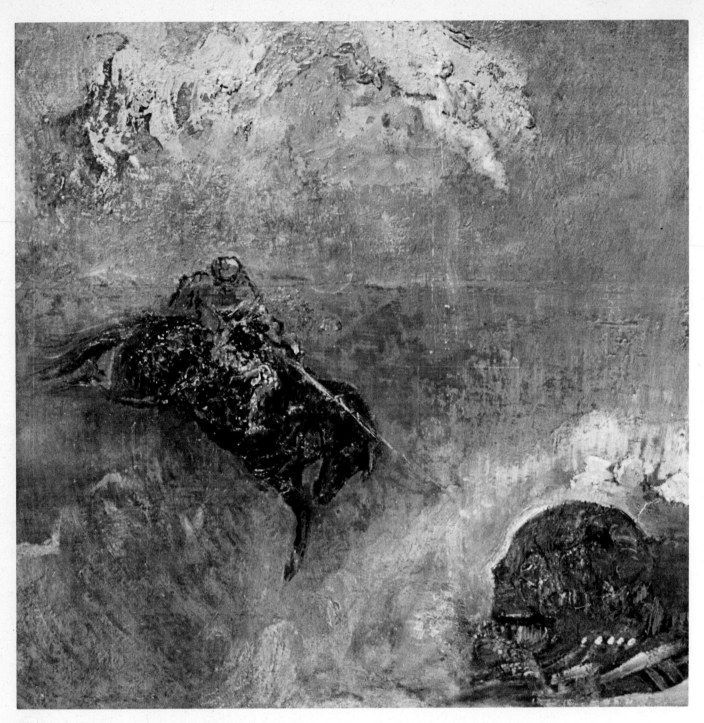

Roger and Angelica / *Roger et Angélique* *c* 1908–10
Oil on cardboard 30×29 cm
(Rijksmuseum Kröller-Müller, Otterlo)

Oannes *c* 1910
Oil on canvas 64×49 cm
(Rijksmuseum Kröller-Müller, Otterlo)

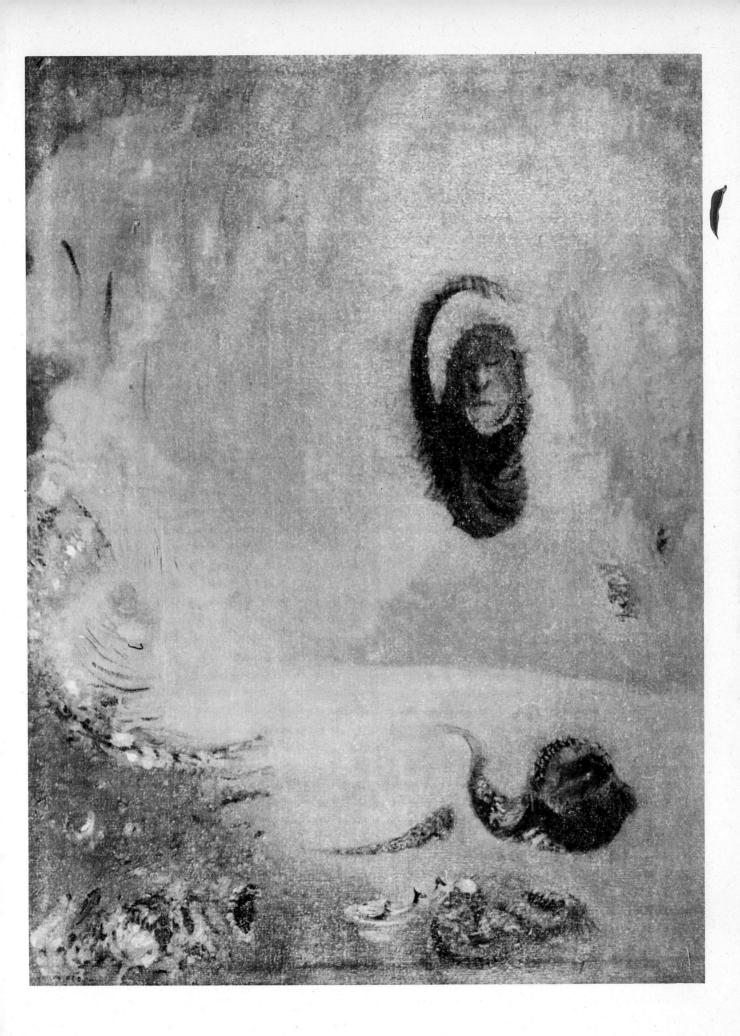

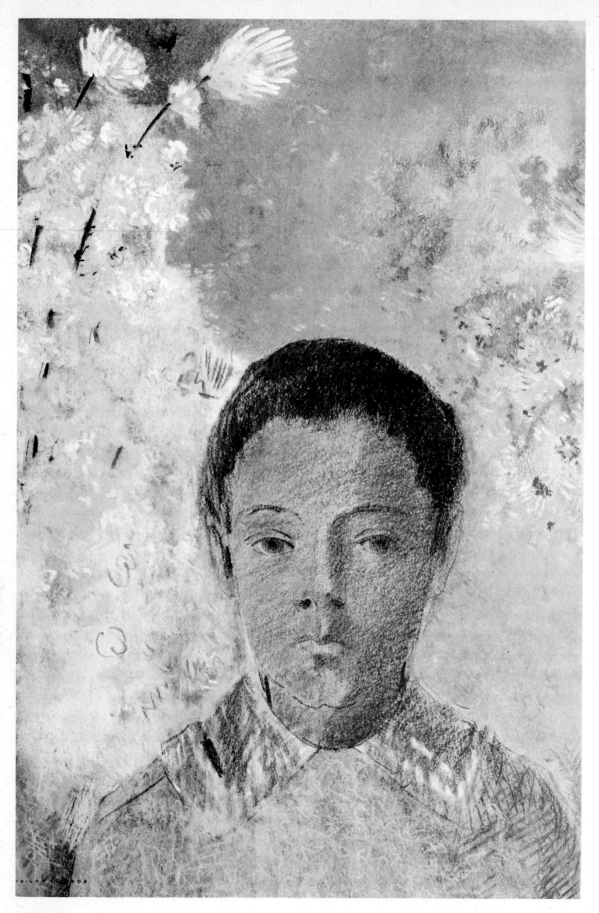

Ari Redon 1897
Pastel 44 × 32 cm
(Art Institute of Chicago; bequest of Kate L. Brewster)

18

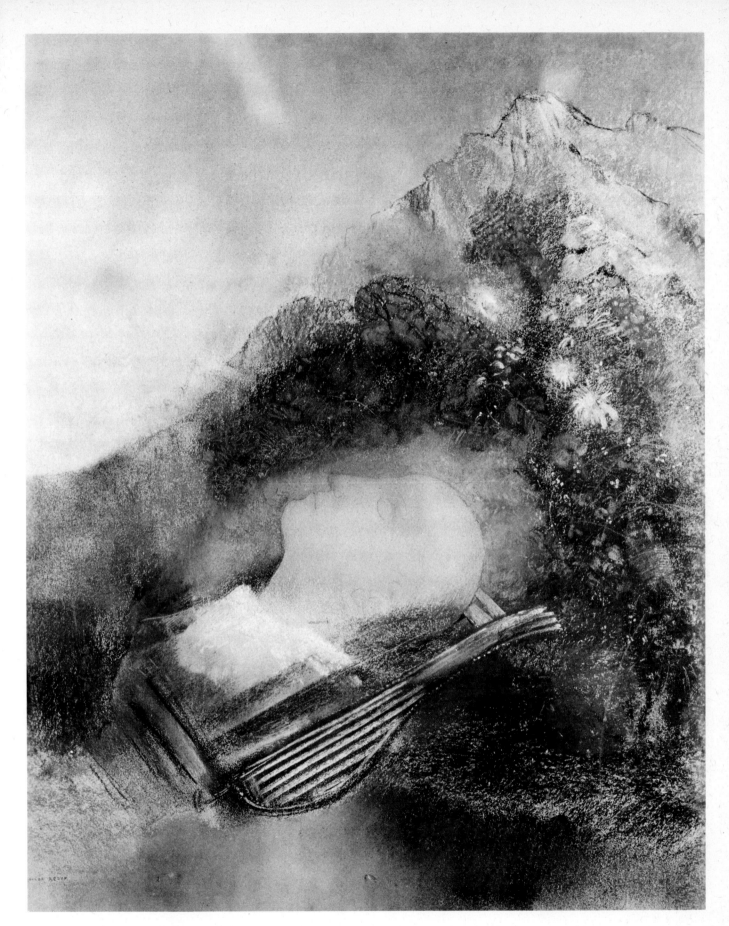

Orpheus / *Orphée* after 1903
Pastel 70 × 57 cm
(Cleveland Museum of Art, gift of J. H. Wade)

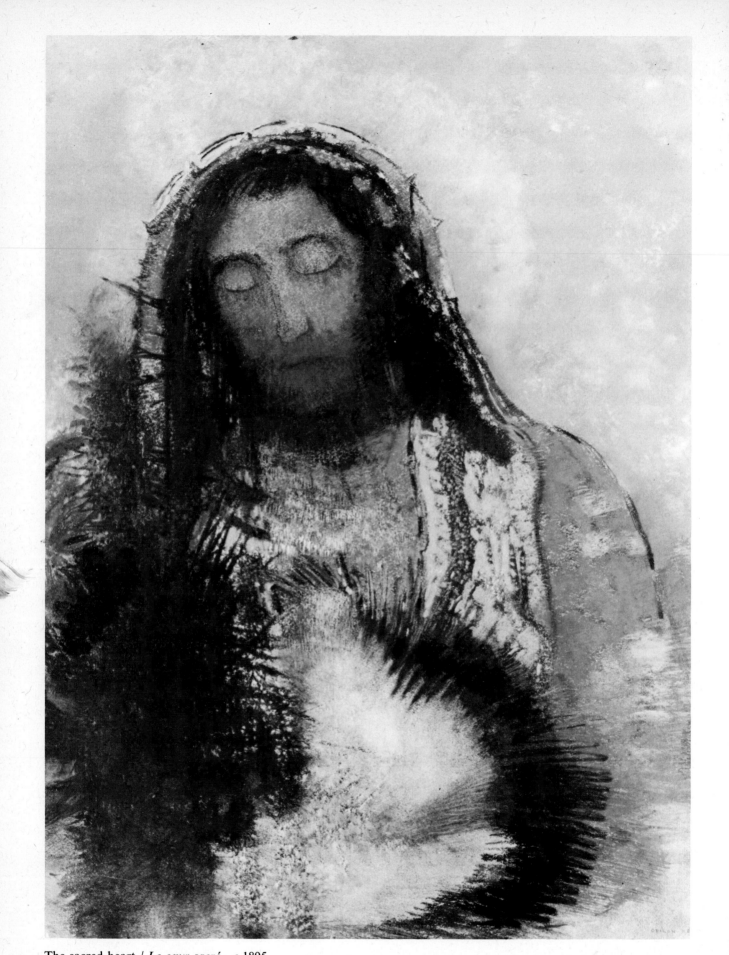

The sacred heart / *Le cœur sacré* *c* 1895
Pastel 60×45 cm
(Musées Nationaux, Paris)

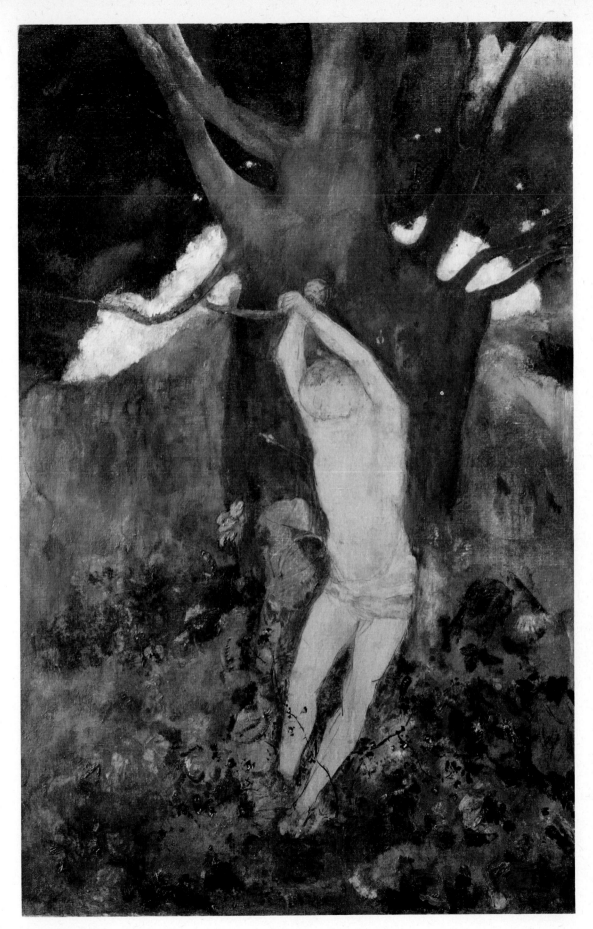

Saint Sebastian c 1910
Oil 92 × 59 cm
(Kunstmuseum, Basle)

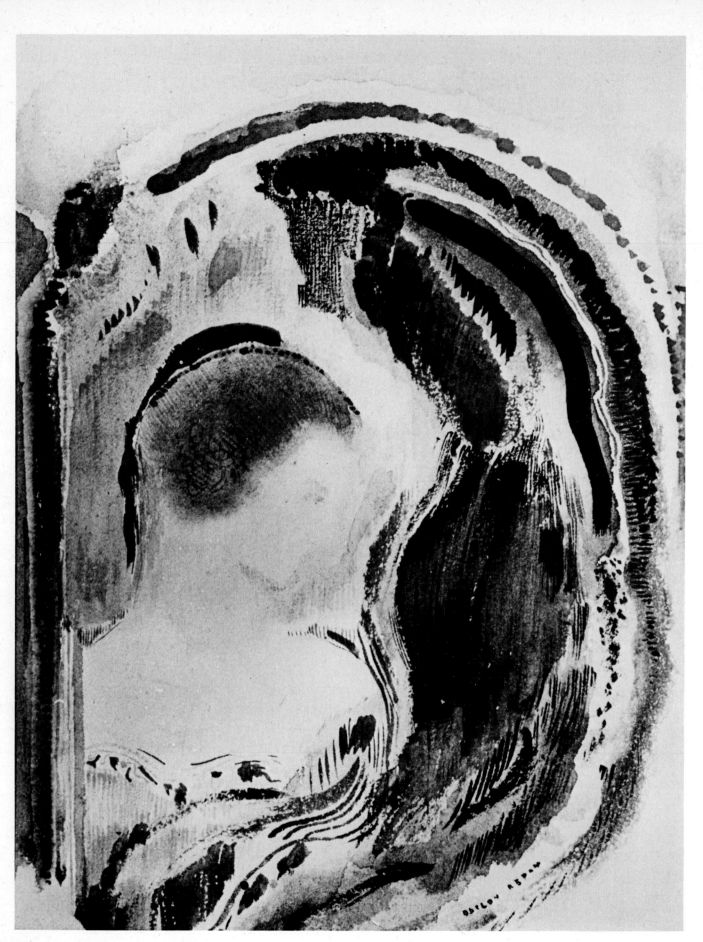

Woman in profile / *Profil de femme*　c 1910
Watercolour　21 × 17 cm
(Musée du Petit-Palais, Paris)

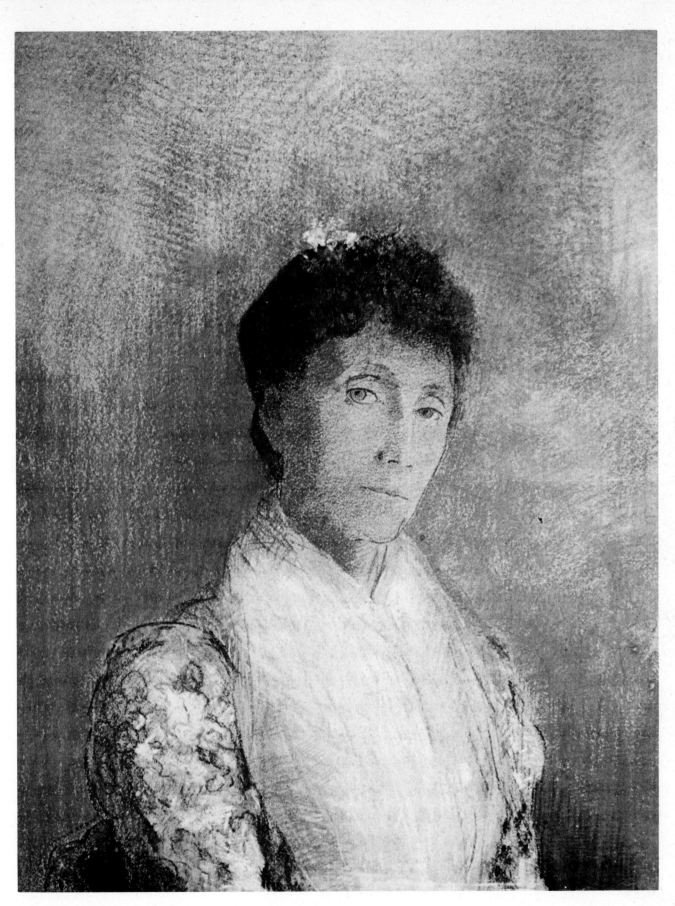

Portrait of Madame Redon / *Portrait de Madame Redon*
c 1890
Pastel 66 × 50 cm
(Rijksmuseum Kröller-Müller, Otterlo)

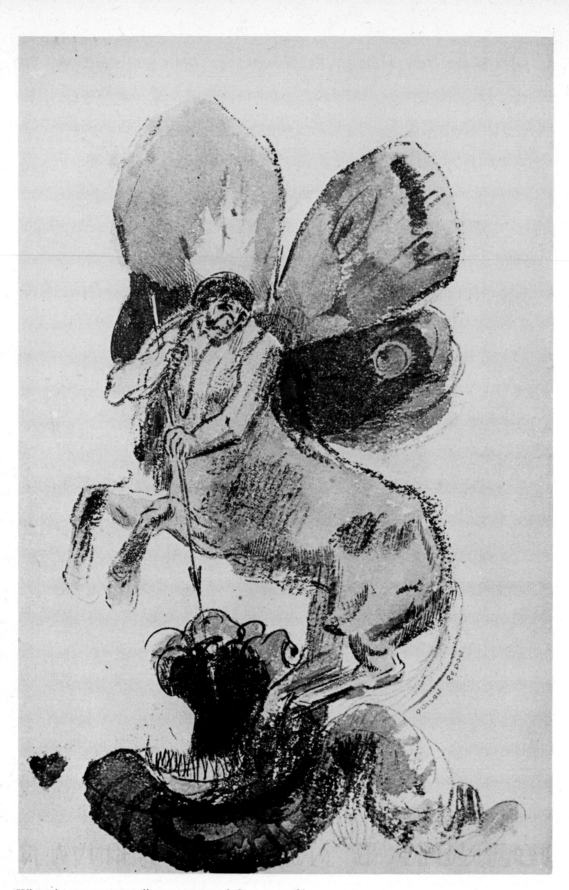

Winged centaur grounding a monster / *Centaure ailé*
terrassant un monstre *c* 1910–14
Pencil and watercolour, touched with sanguine
23 × 15 cm
(Musée du Petit-Palais, Paris)

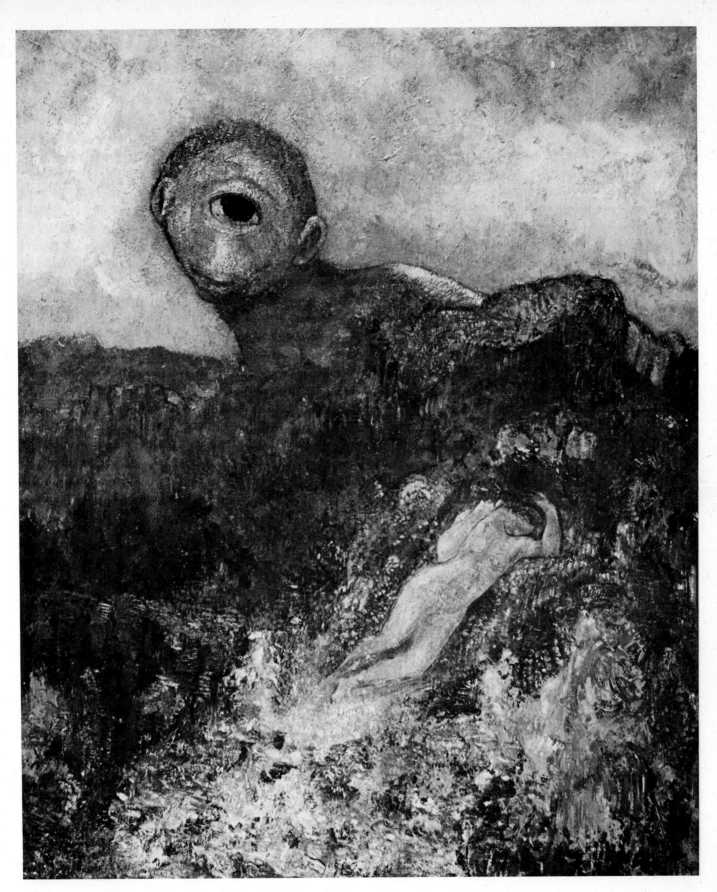

The Cyclops / *Le Cyclope* 1898
Oil on panel 64 × 51 cm
(Rijksmuseum Kröller-Müller, Otterlo)

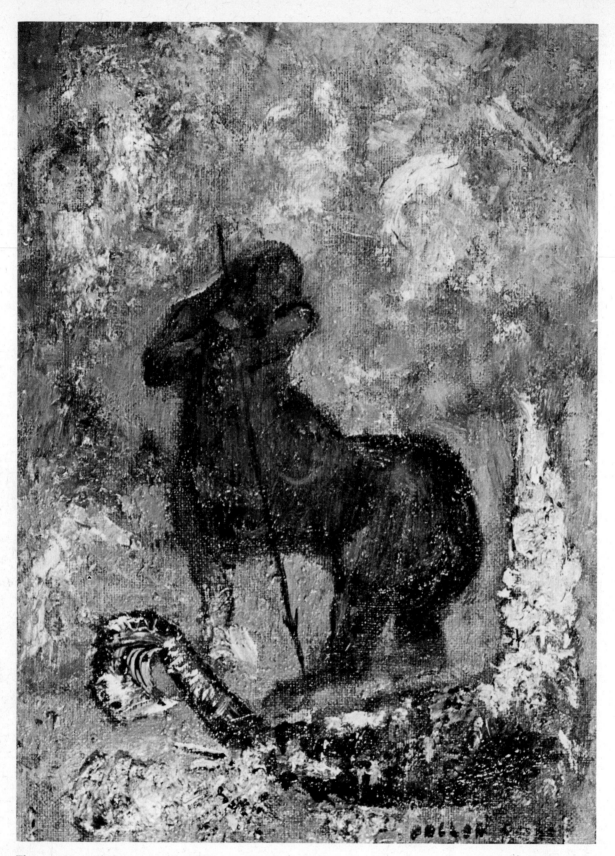

The centaur and the serpent / *Centaure et serpent* *c* 1908
Oil on canvas mounted on cardboard 25 × 18 cm
(Rijksmuseum Kröller-Müller, Otterlo)

Opposite

Nude / *Nu*
Oil on canvas 46 × 38 cm
(Private collection)

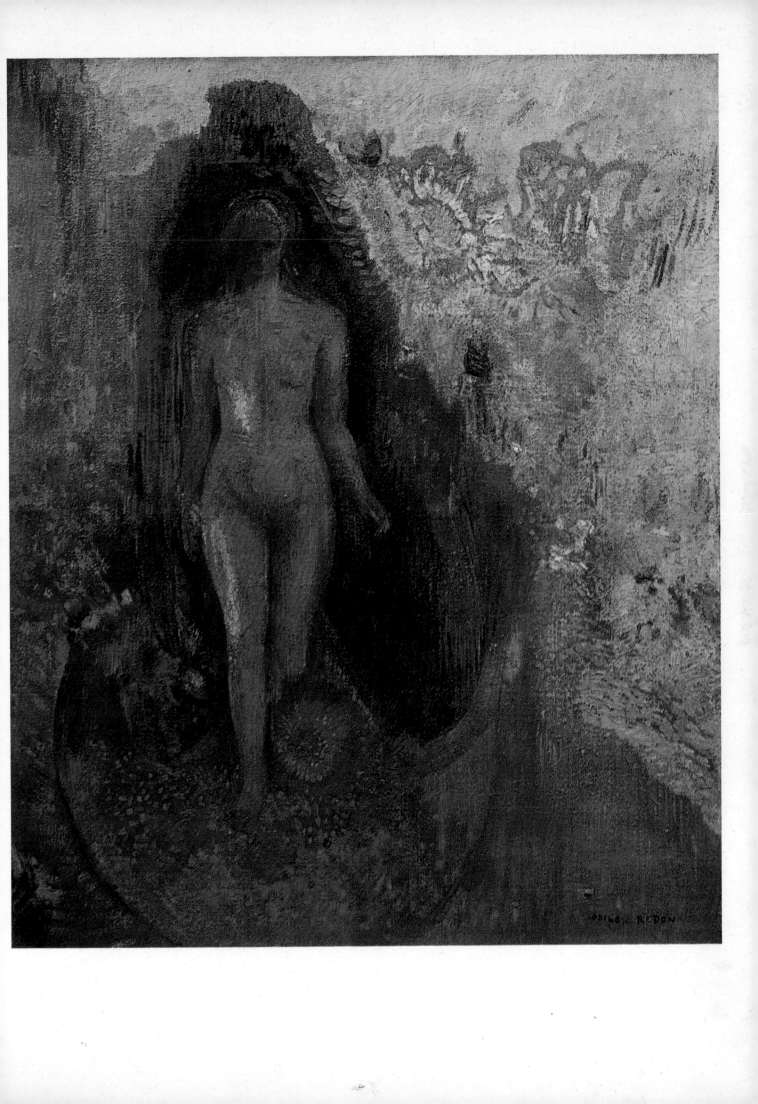

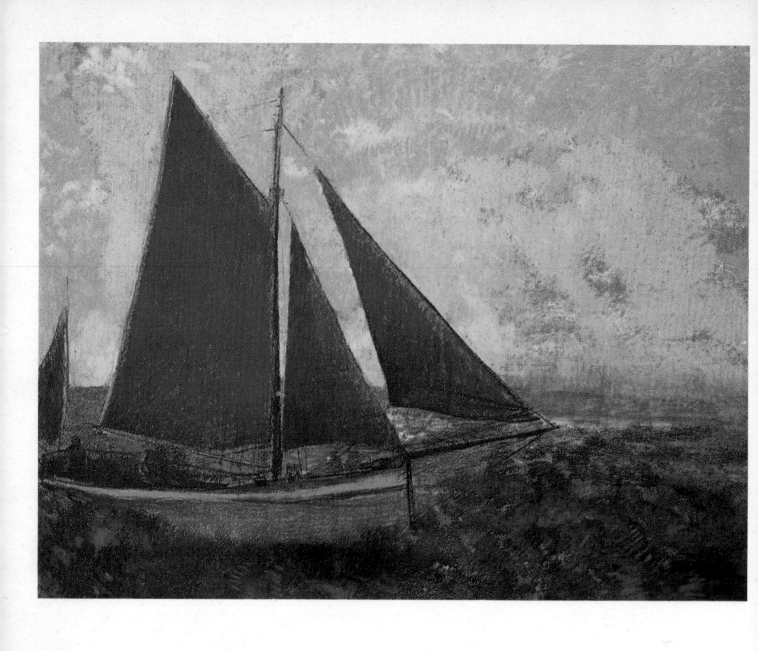

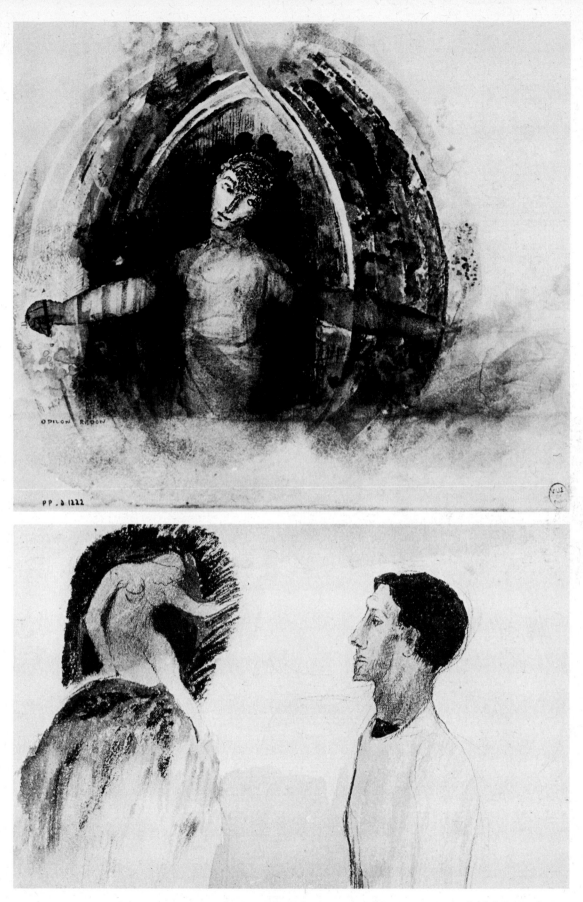

Opposite

Ship with red sails / *Bateau aux voiles rouges*
Pastel 48 × 63.5 cm
(Fuji Gallery, Tokyo)

Bust of a woman with arms outstretched / *Buste de femme, les bras étendus* c 1910–14
Watercolour 17 × 20 cm
(Musée du Petit-Palais, Paris)

Man and woman in front of the sun / *Homme et femme devant le soleil* c 1910–14
Watercolour 14 × 23 cm
(Musée du Petit-Palais, Paris)

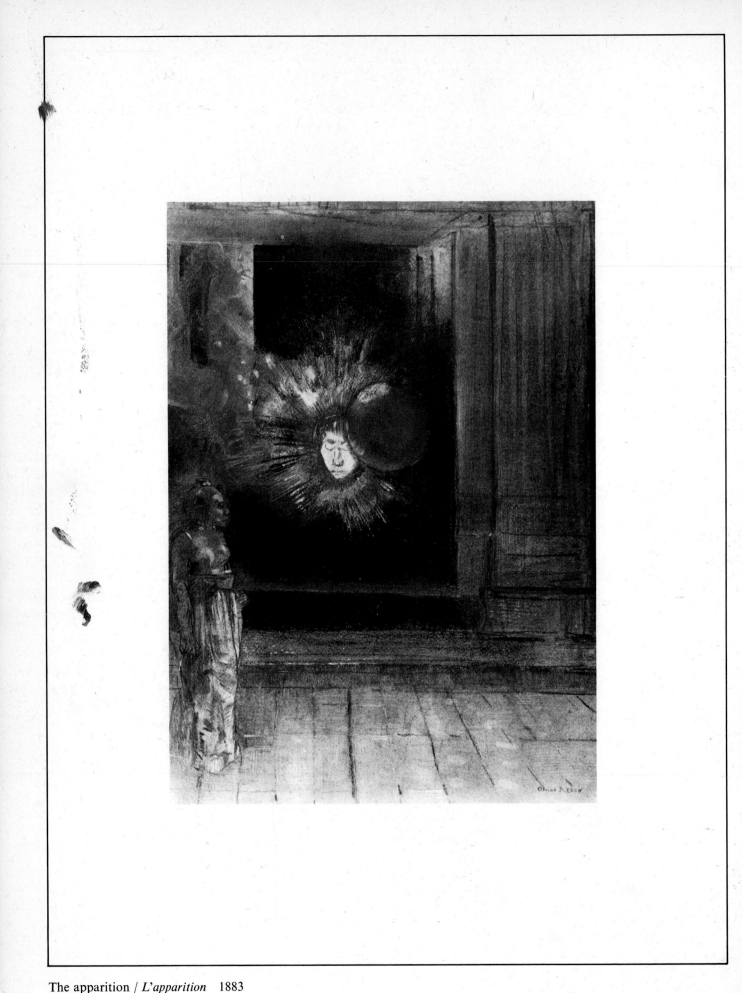

The apparition / *L'apparition* 1883
Charcoal 58 × 44 cm
(Musée des Beaux-Arts, Bordeaux; photo A. Danvers)

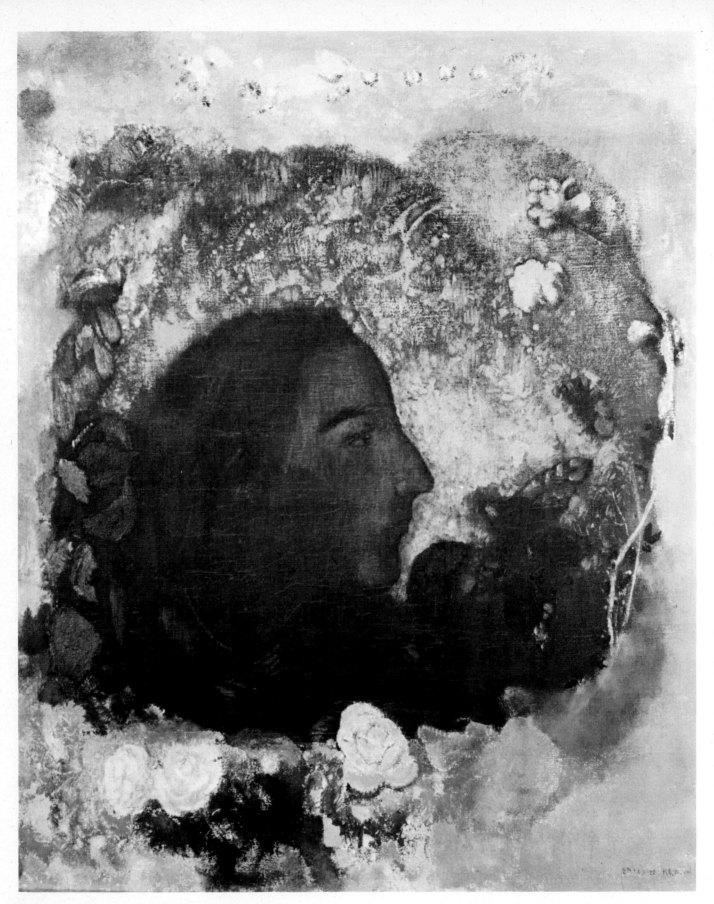

Portrait of Gauguin / *Portrait de Gauguin* 1904
Oil on canvas 66 × 55 cm
(Musées Nationaux, Paris)

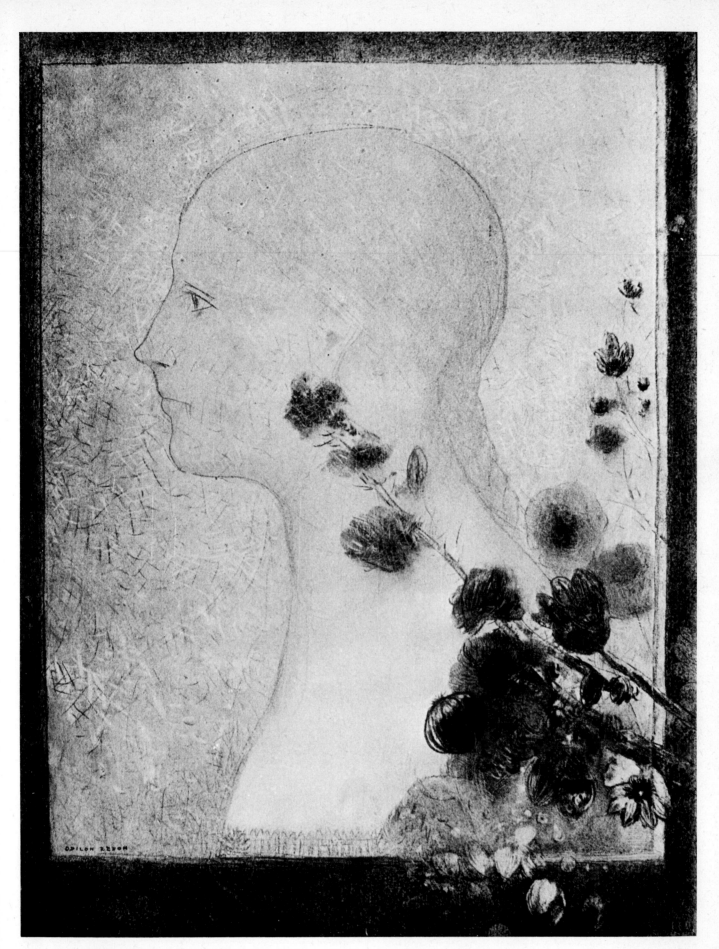

Woman in profile with flowers / *Profil de femme avec*
fleurs c 1890–95
Charcoal 50×37 cm
(Rijksmuseum Kröller-Müller, Otterlo)

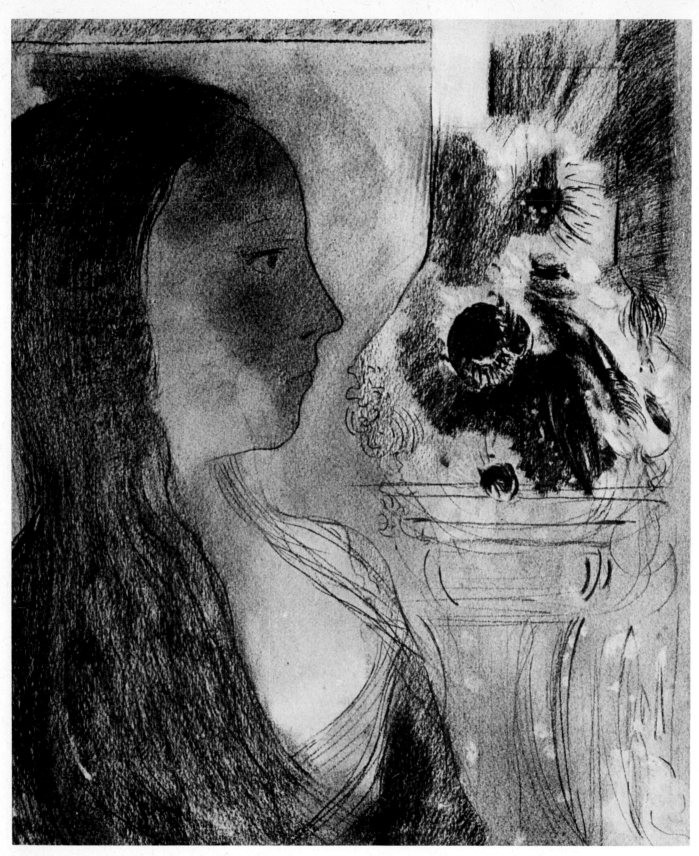

Woman with flowers / *Femme et fleurs* *c* 1890–95
Charcoal 44×37 cm
(Rijksmuseum Kröller-Müller, Otterlo)

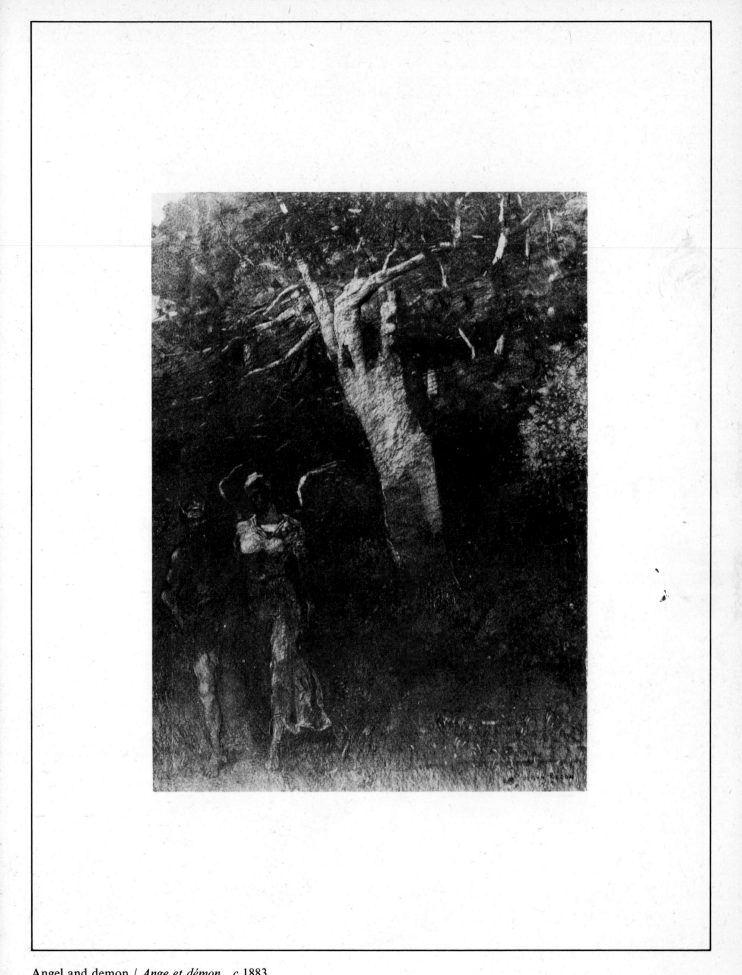

Angel and demon / *Ange et démon* *c* 1883
Charcoal 45×36 cm
(Musée des Beaux-Arts, Bordeaux; photo A. Danvers)

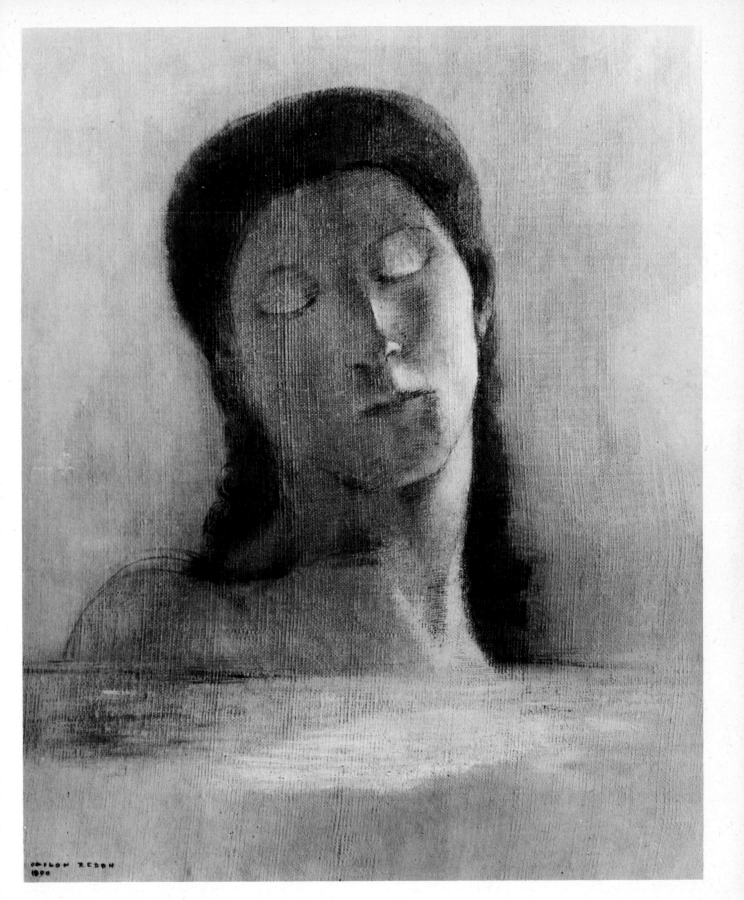

Closed eyes / *Les yeux clos* 1890
Oil on canvas mounted on board 44 × 36 cm
(Musées Nationaux, Paris)

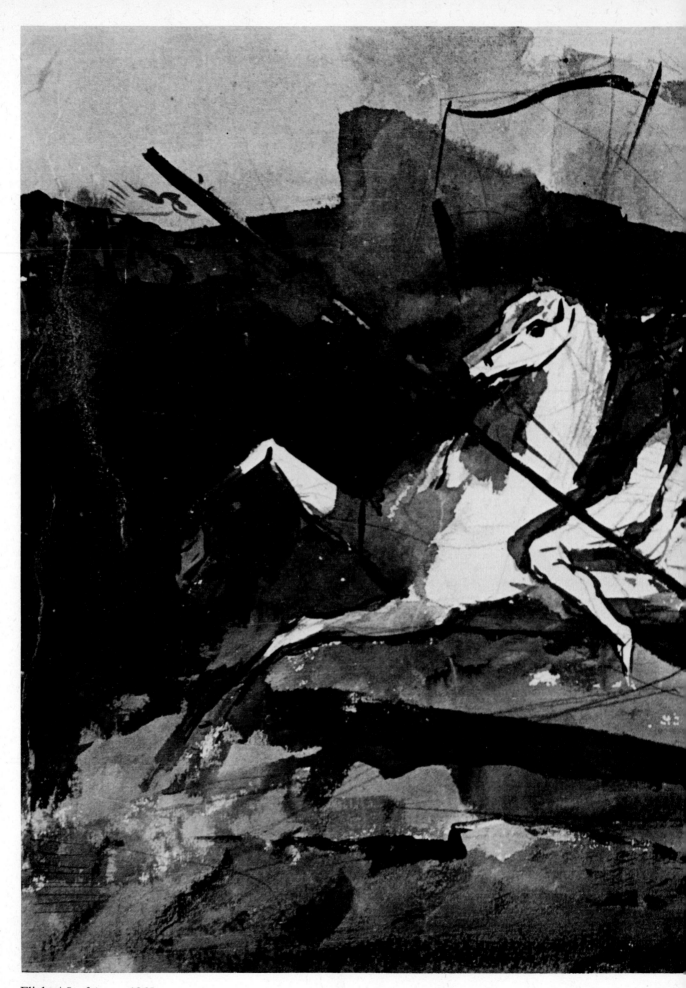

Flight / *La fuite* *c* 1865
Indian ink wash 30 × 46 cm
(Rijksmuseum Kröller-Müller, Otterlo)

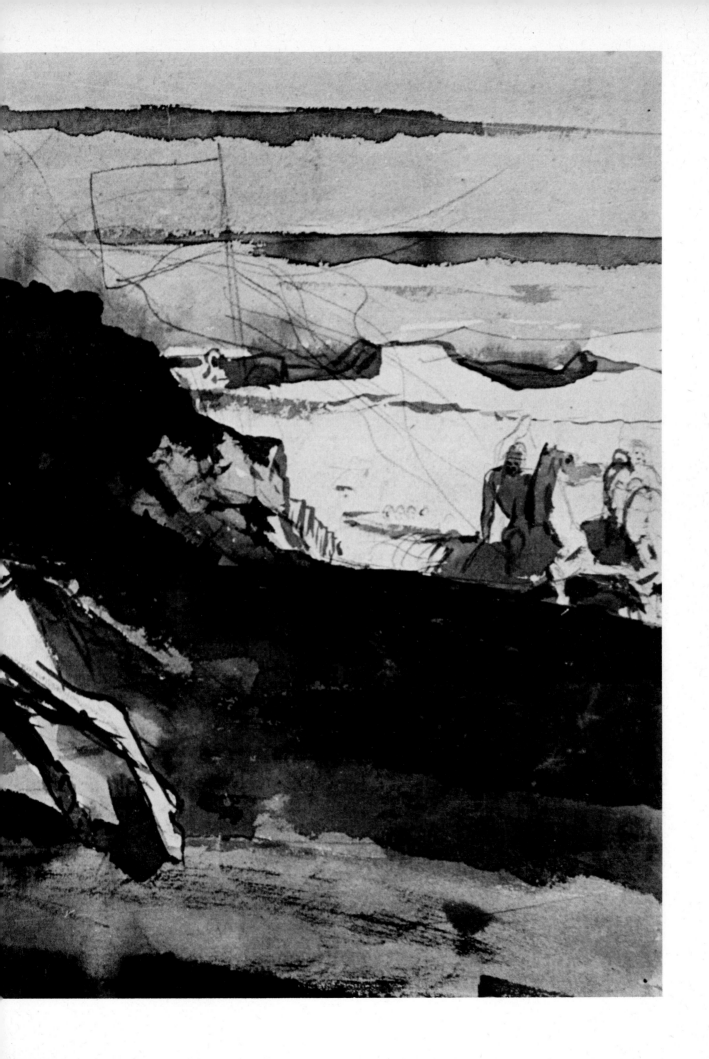

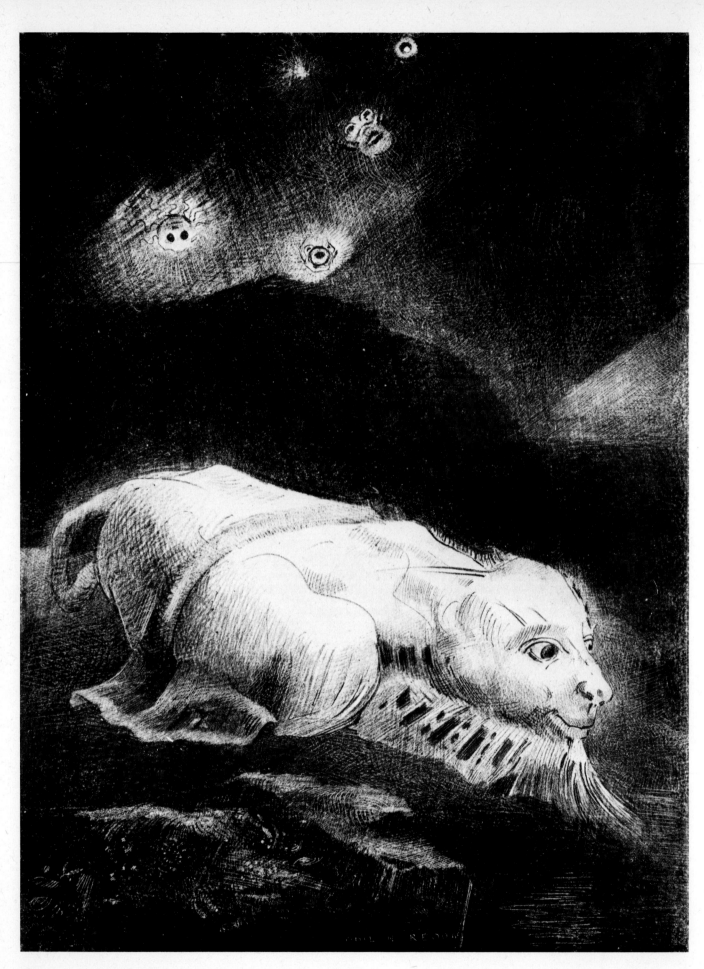

When life was awakening in the depths of the dark
matter / *Quand s'éveillait la vie au fond de la matière
obscure*, No. 1 of *Les Origines* 1883
Lithograph 27.5×20.3 cm

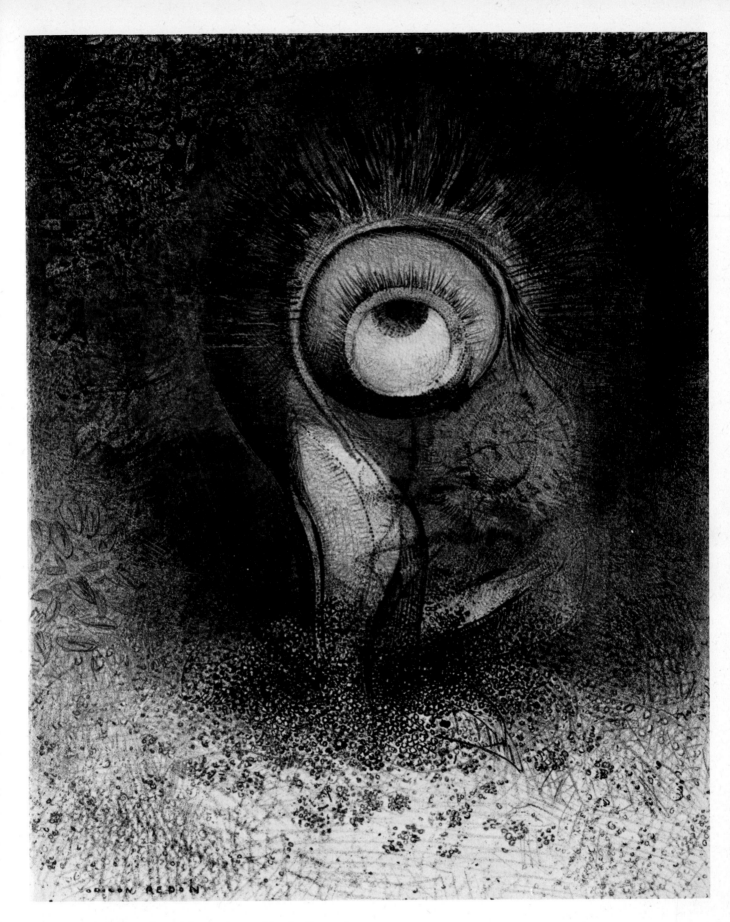

There was perhaps a first vision attempted in the flower /
Il y eut peut-être une vision première essayée dans la fleur,
No. 2 of *Les Origines* 1883
Lithograph 22.3 × 17.2 cm

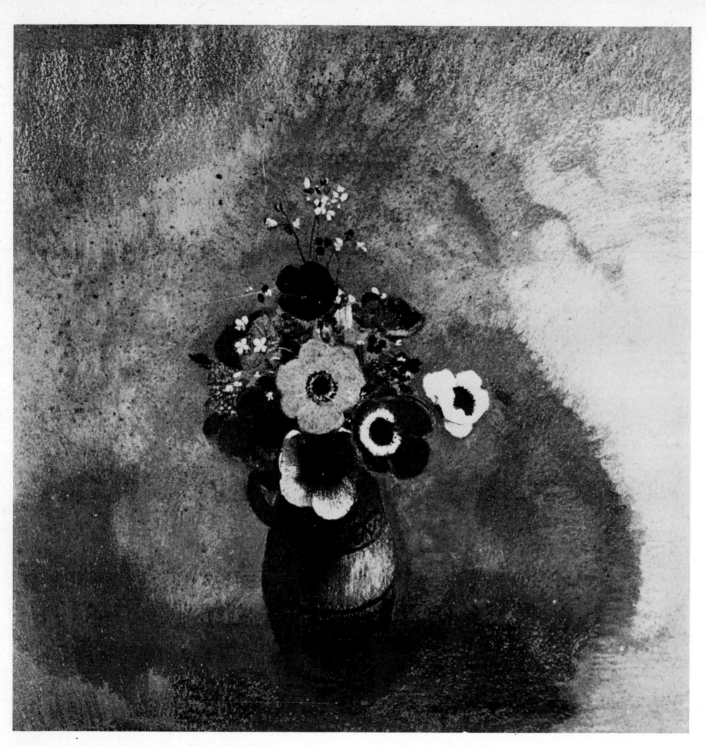

Bouquet of anemones / *Bouquet d'anémones* after 1912
Pastel 62 × 62 cm
(Musée du Petit-Palais, Paris)

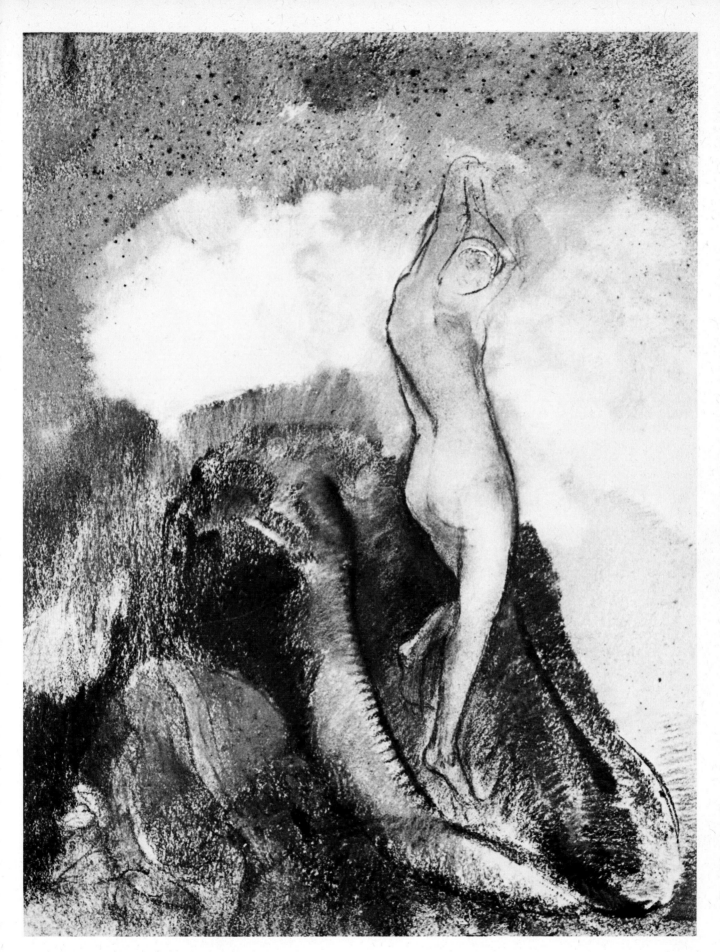

Birth of Venus / *La naissance de Vénus* c 1910
Pastel 83 × 64 cm
(Musée du Petit-Palais, Paris)

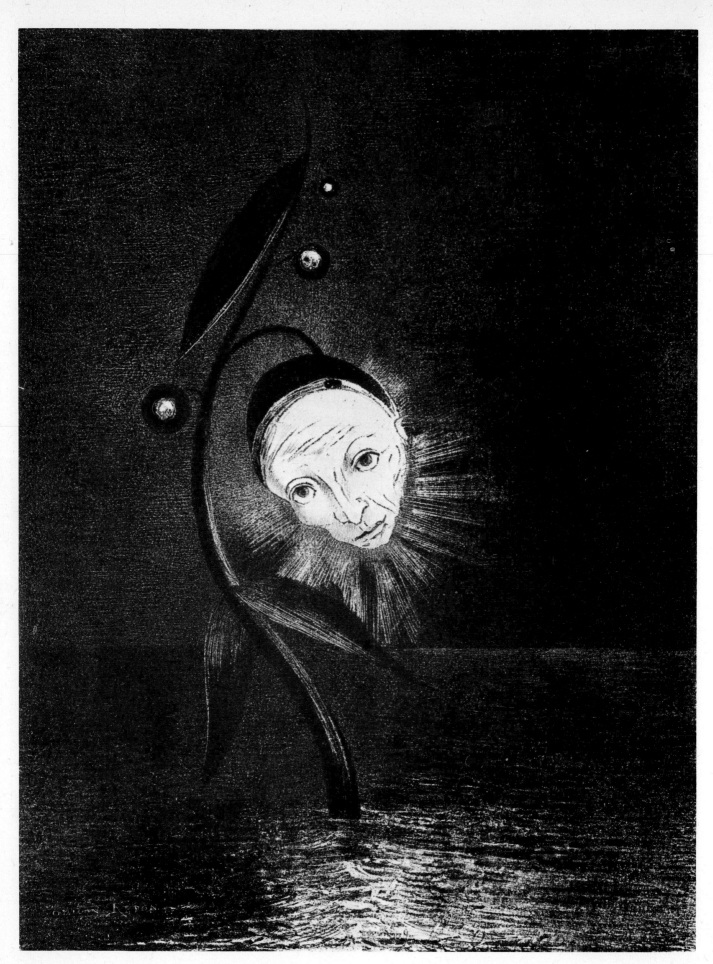

The marsh flower, a sad, human head / *La fleur du marécage, une tête humaine et triste*, No. 2 of *Hommage à Goya* 1885
Lithograph 27.5×20.5 cm

42

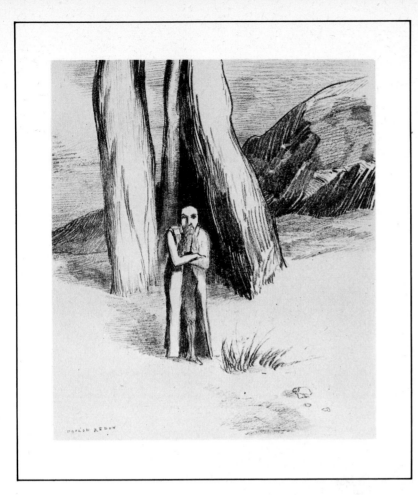

A madman in a dismal landscape / *Un fou dans un morne
paysage*, No. 3 of *Hommage à Goya* 1885
Lithograph 22.6×19.3 cm

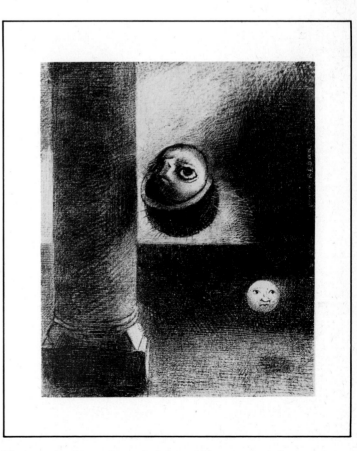

There were also embryonic beings / *Il y eut aussi des
êtres embryonnaires*, No. 4 of *Hommage à Goya* 1885
Lithograph 23.8×19.7 cm

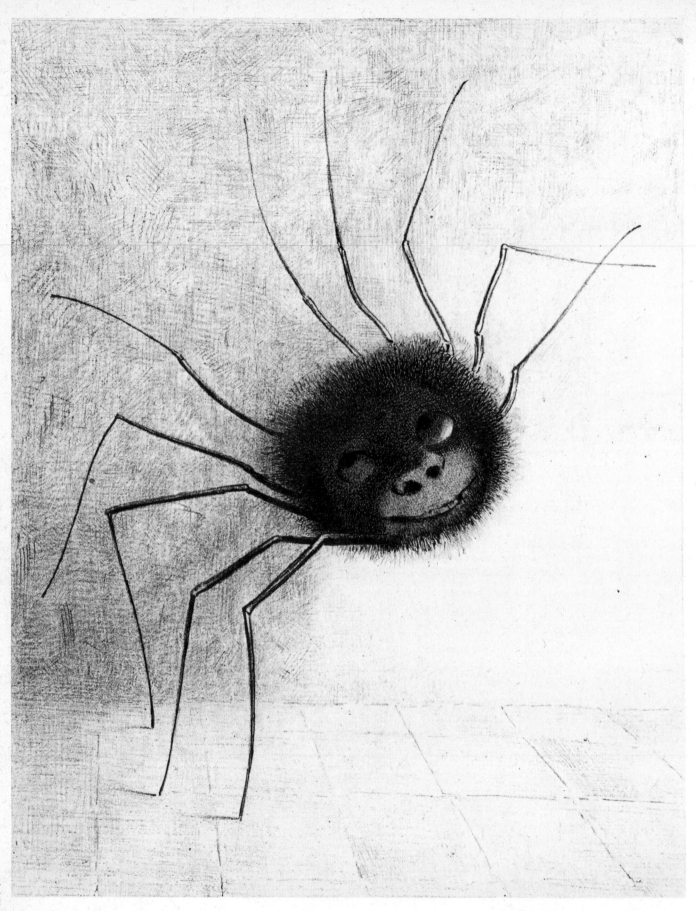

Spider / *Araignée*　1887
Lithograph　26×21.5 cm

Opposite

Profile of a woman / *Profil de femme*
Oil on canvas　65×50 cm
(Galerie Beyeler, Basle)

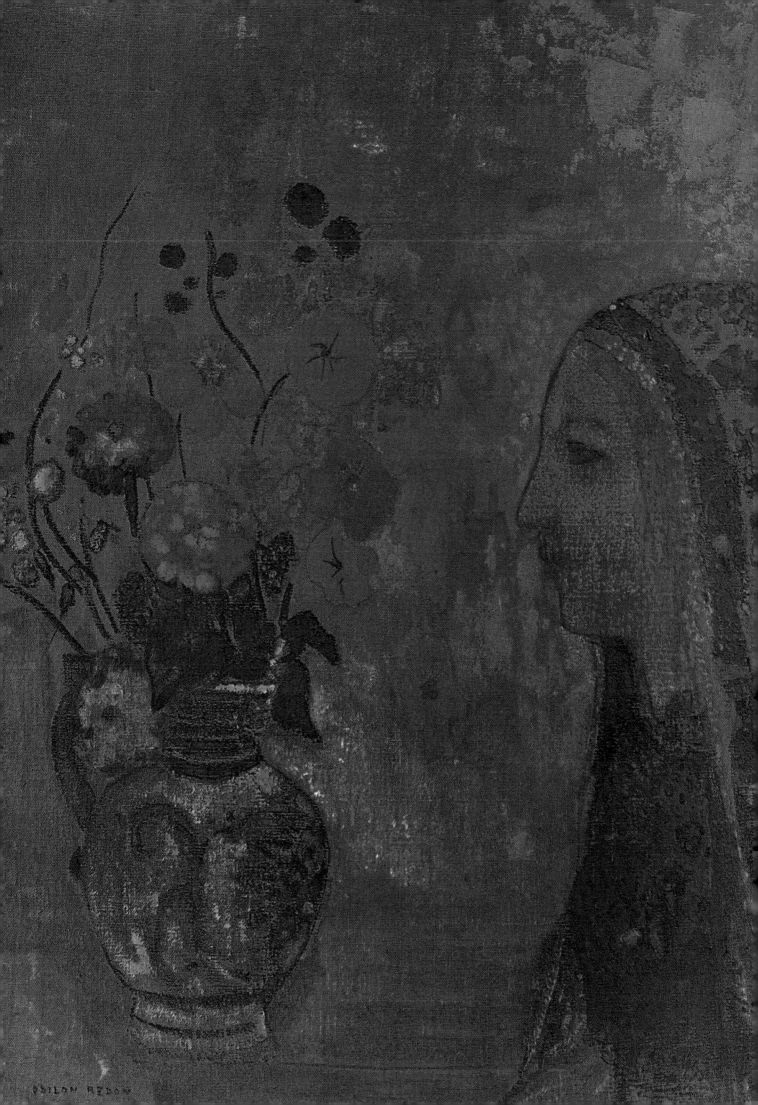

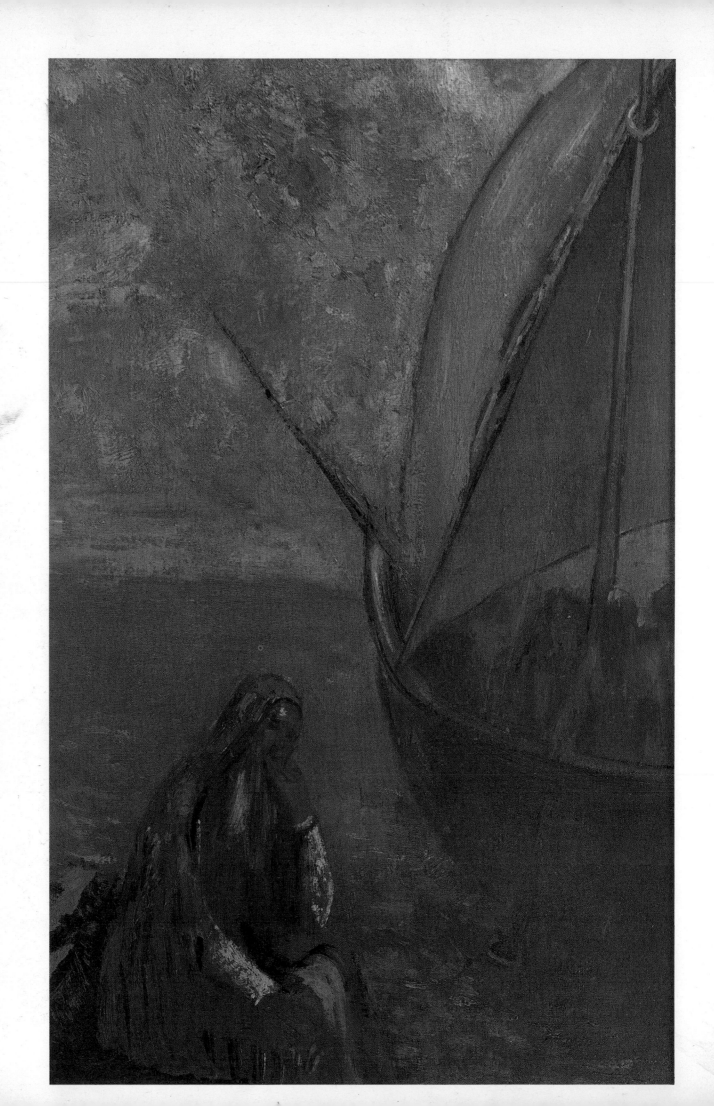

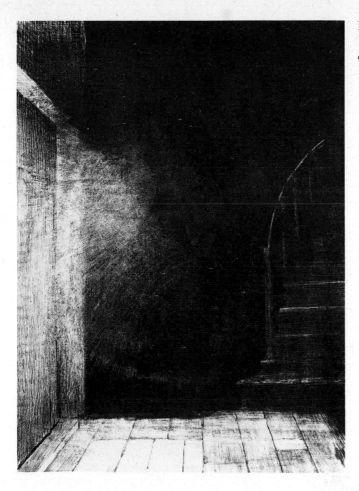

I saw a large pale light / *Je vis une lueur large et pâle*, No. 2 of *La Maison hantée* (translation of *The Haunted and the Haunters* by Edward Bulwer-Lytton) 1896
Lithograph 23×17 cm

It was a hand which seemed as much of flesh and blood as my own / *Selon toute apparence, c'était une main de chair et de sang comme la mienne*, No. 4 of *La Maison hantée* (translation of *The Haunted and the Haunters* by Edward Bulwer-Lytton) 1896
Lithograph 24.5×17.8 cm

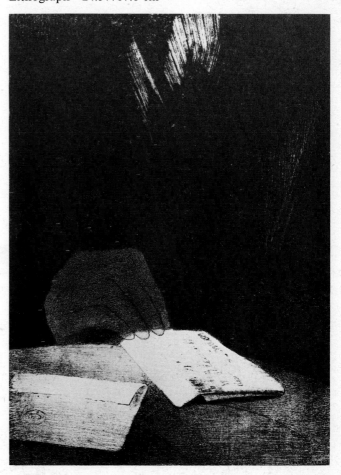

Opposite

The departure / *Le départ*
Oil on board 41×27 cm
(Courtesy of Arthur Tooth & Sons Ltd)

47

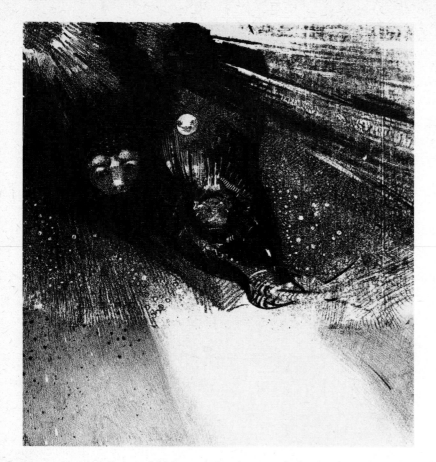

Larvae so bloodless and hideous / *Des larves si hideuses*,
No. 5 of *La Maison hantée* (translation of *The Haunted
and the Haunters* by Edward Bulwer-Lytton) 1896
Lithograph 17.9×17 cm

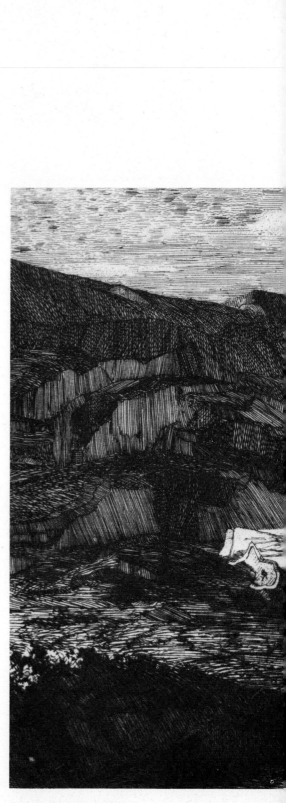

Fear / *La peur* 1865
Etching 11.2×20 cm

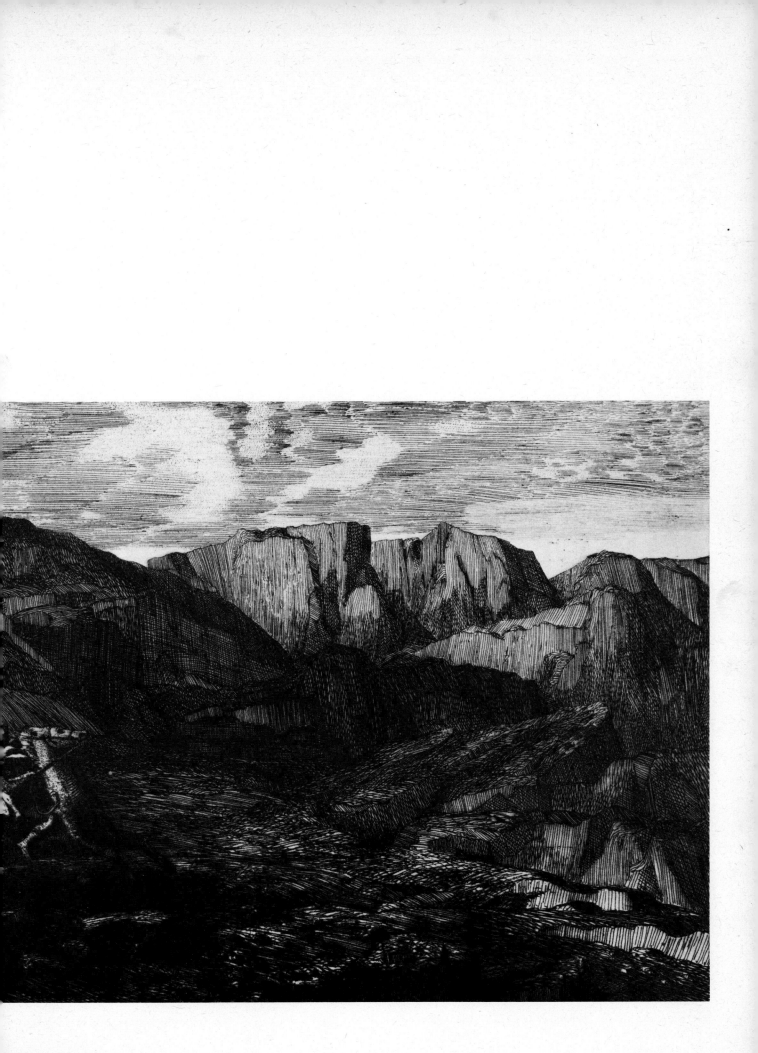

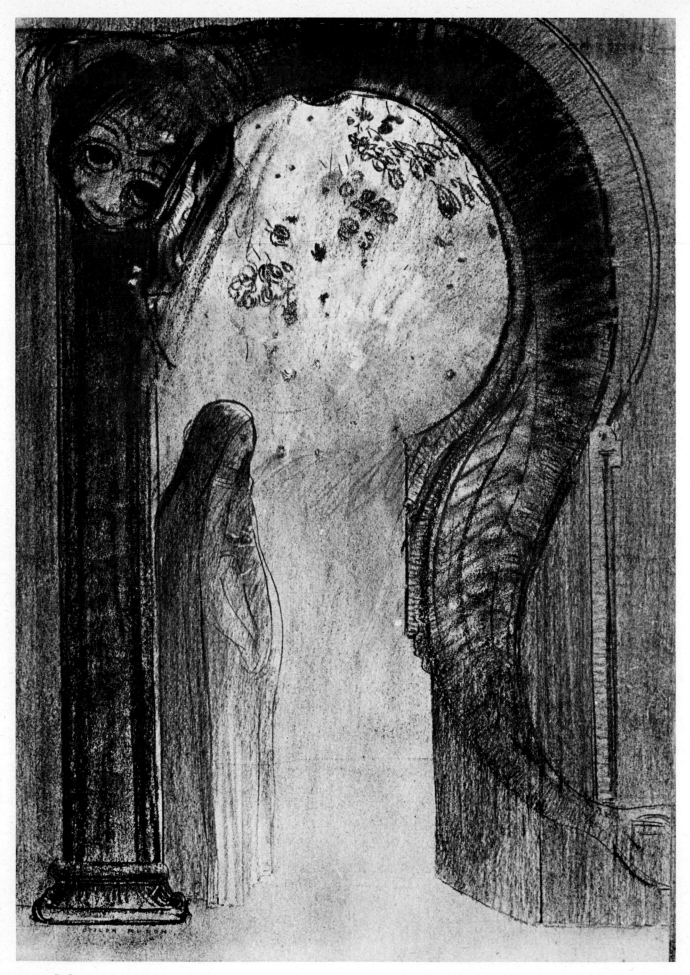

Woman and snake / *Femme et serpent* *c* 1885–90
Charcoal 51×36 cm
(Rijksmuseum Kröller-Müller, Otterlo)

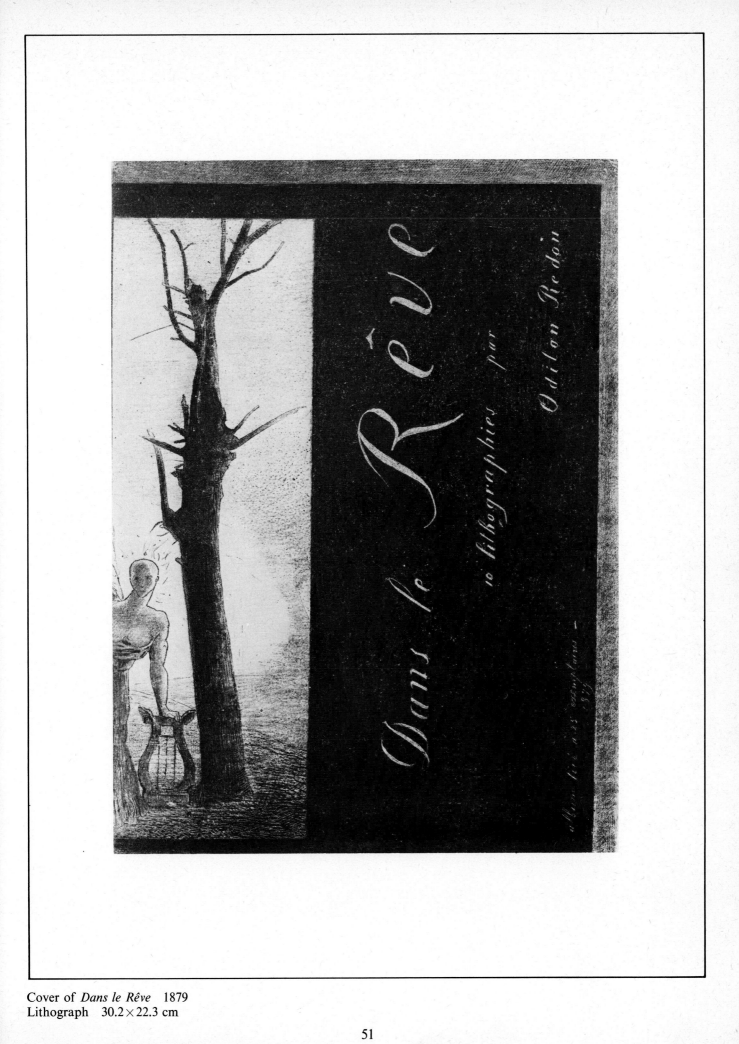

Cover of *Dans le Rêve* 1879
Lithograph 30.2×22.3 cm

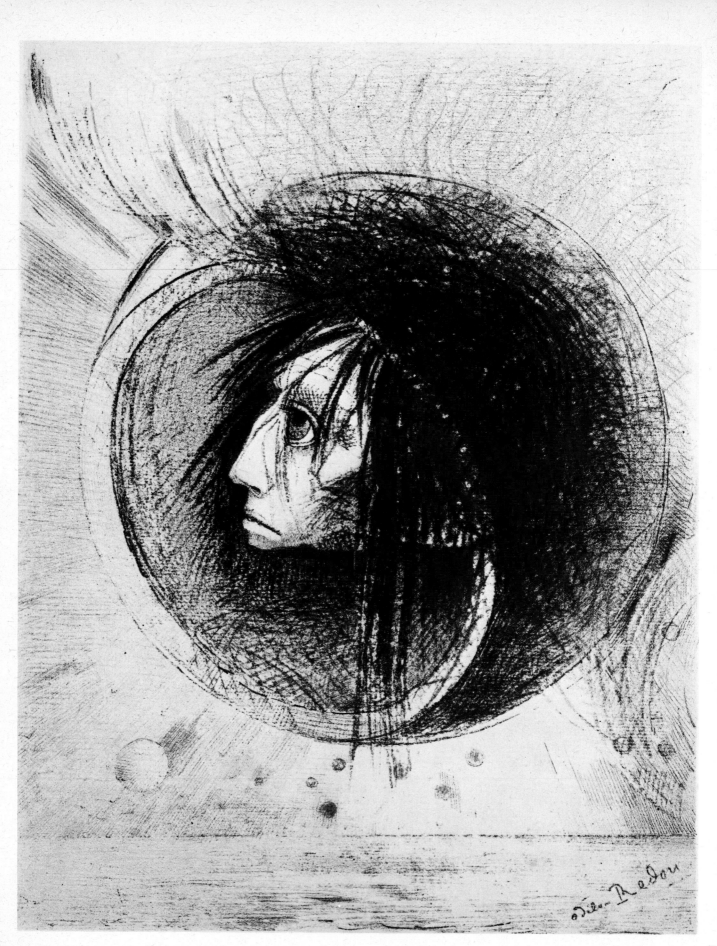

Blossoming / *Eclosion*, No. 1 of *Dans le Rêve* 1879
Lithograph 32.8 × 25.7 cm

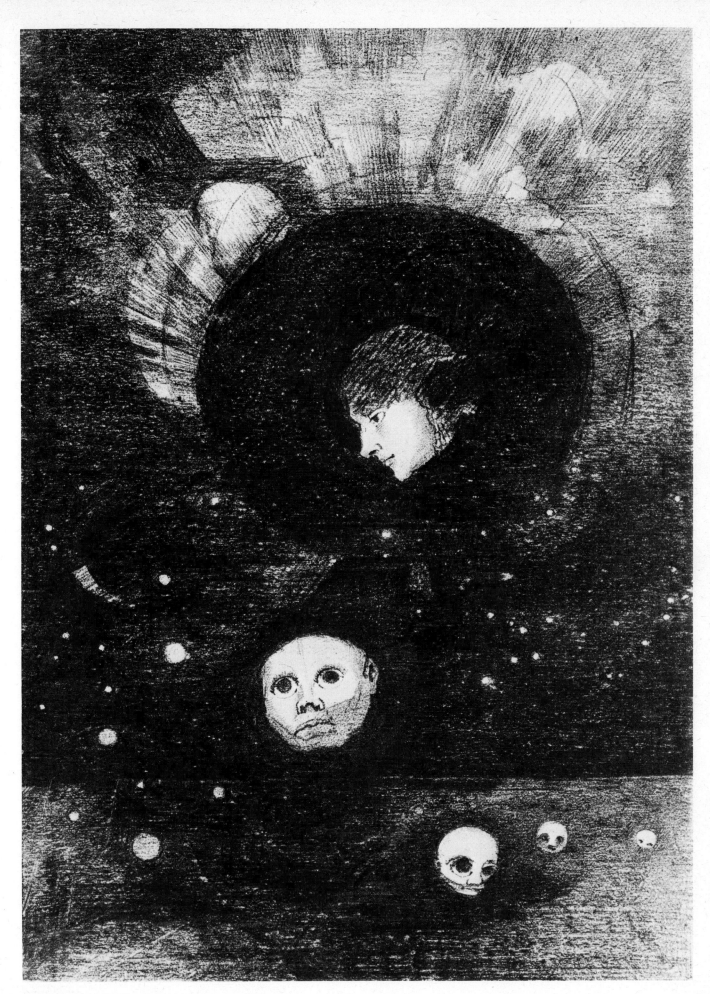

Germination, No. 2 of *Dans le Rêve* 1879
Lithograph 27.3×19.4 cm

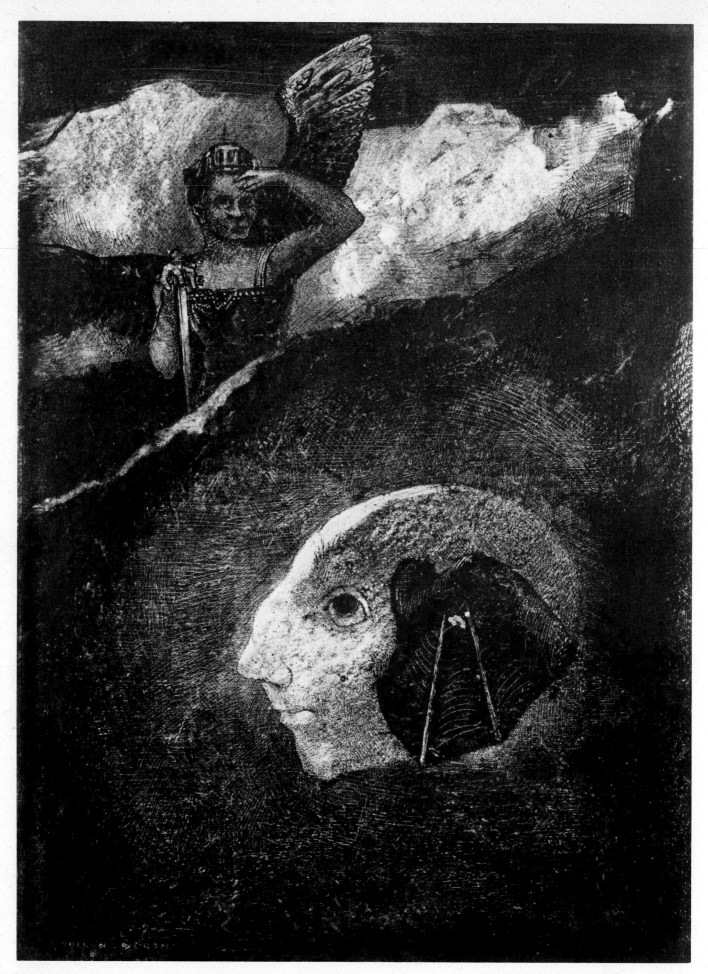

Limbo / *Limbes*, No. 4 of *Dans le Rêve* 1879
Lithograph 30.7×22.3 cm

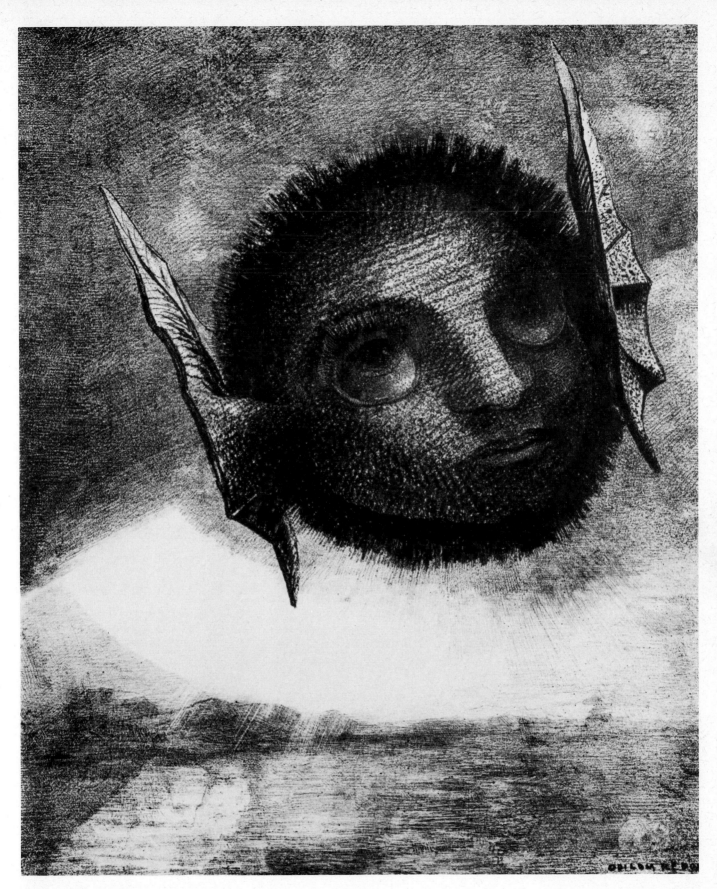

Gnome, No. 6 of *Dans le Rêve* 1879
Lithograph 27.2×22 cm

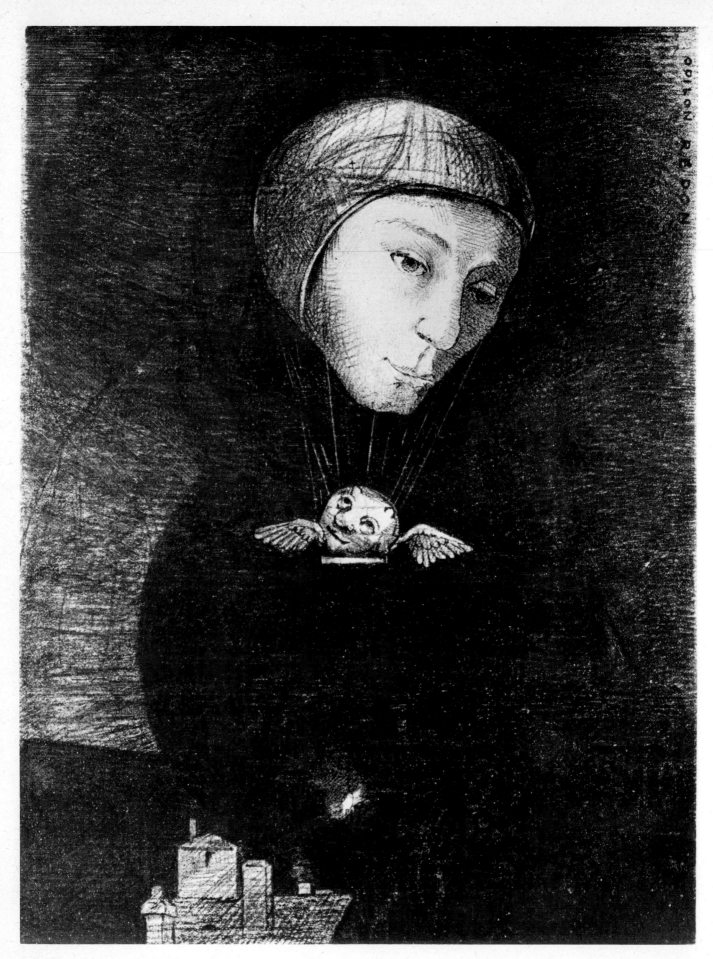

Sad ascent / *Triste montée*, No. 9 of *Dans le Rêve* 1879
Lithograph 26.7 × 20 cm

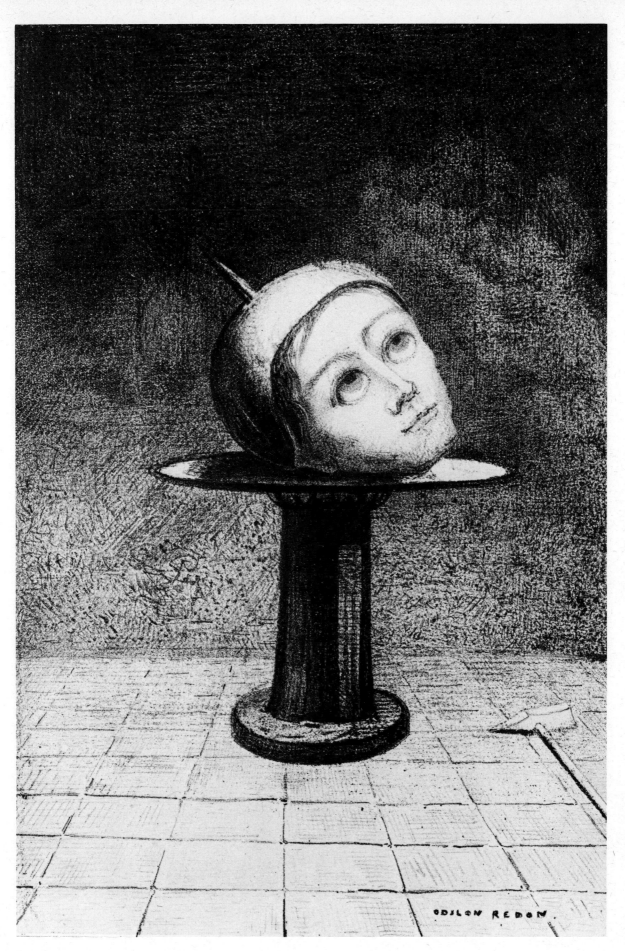

On the dish / *Sur la coupe*, No. 10 of *Dans le Rêve* 1879
Lithograph 24.4 × 16 cm

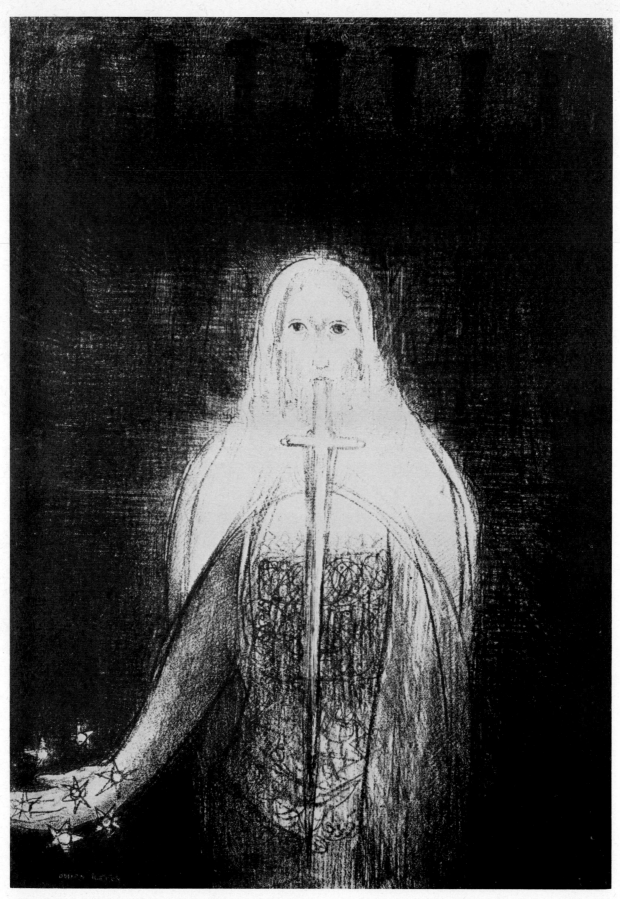

And he had in his right hand seven stars; and out of his
mouth went a sharp two-edged sword / *Et il avait dans sa
main droite sept étoiles, et de sa bouche sortait une épée
aiguë à deux tranchants*, No. 1 of *Apocalypse de
Saint-Jean* 1899
Lithograph 29.2 × 20.9 cm

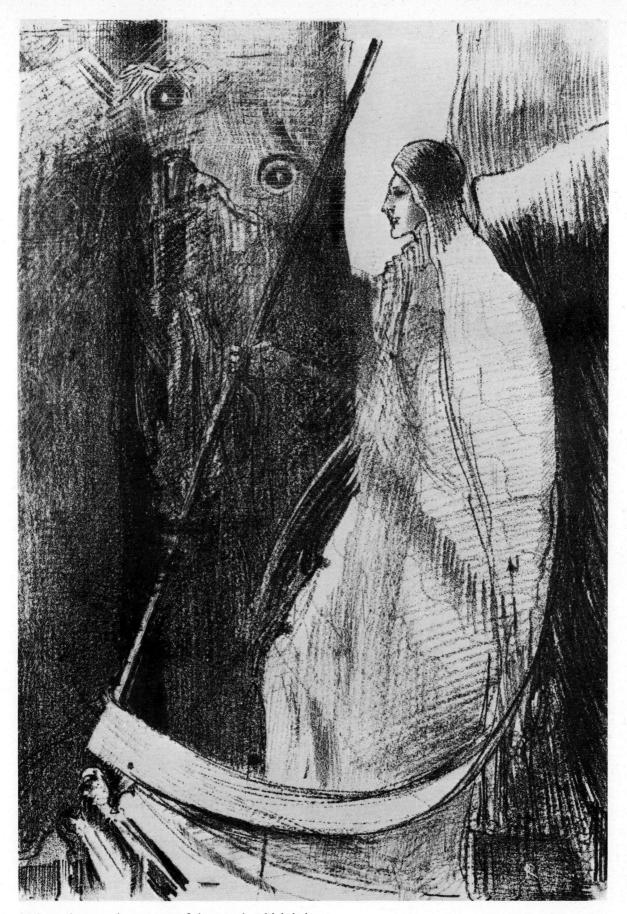

And another angel came out of the temple which is in
heaven, and he also having a sharp sickle / *Et un autre
ange sortit du temple qui est au ciel, ayant lui aussi une
faucille tranchante*, No. 7 of *Apocalypse de Saint-Jean*
1899
Lithograph 31.3×21.2 cm

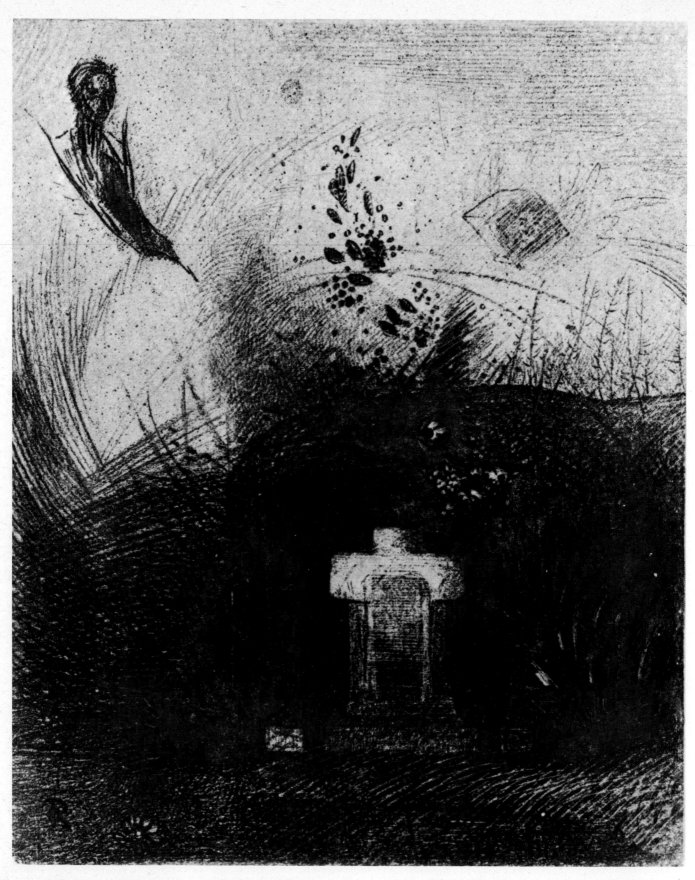

If on a close dark night a good Christian, out of charity,
behind some old ruin, buries your arched body / *Si par
une nuit lourde et sombre, un bon Chrétien, par charité,
derrière quelque vieux décombre, enterre votre corps voûté,*
No. 4 of *Les Fleurs du Mal* 1890
Drawing reproduced by the Evely process 23.2 × 18.3 cm

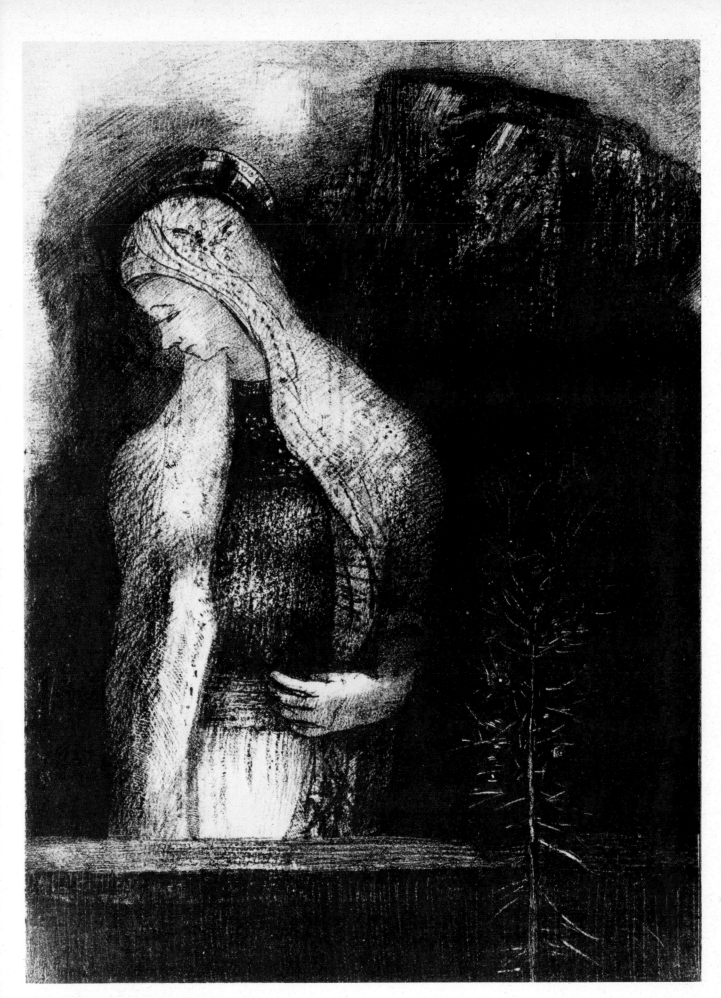

Saint and thistle / *Sainte et chardon* 1891
Lithograph 28.5×20.7 cm

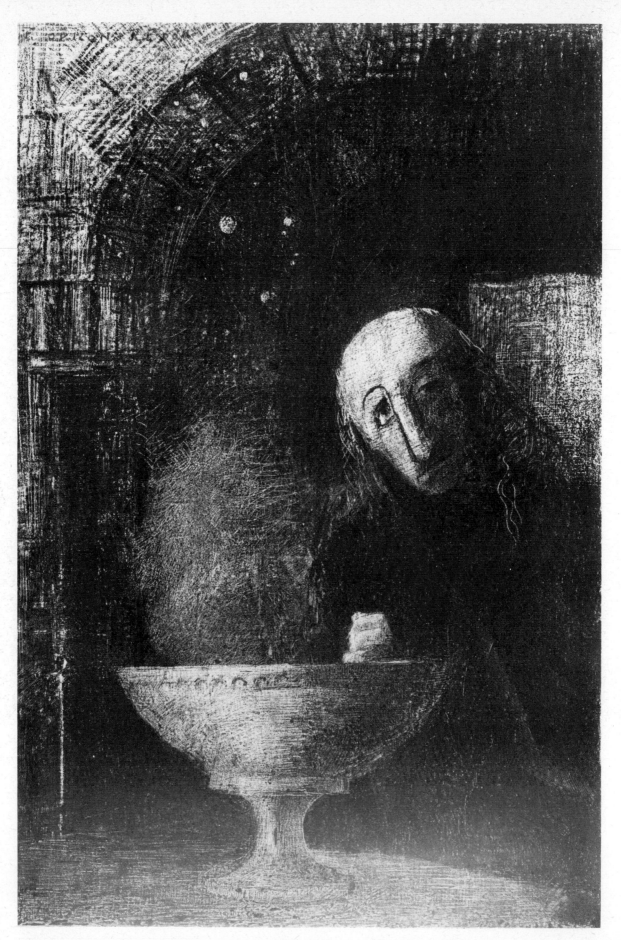

And the searcher was engaged in an infinite search / *Et le chercheur était à la recherche infini*, No. 6 of *La Nuit* 1886
Lithograph 27.6 × 18.1 cm

Opposite
Rider on the beach with two boats / *Cavalier sur une plage aux deux barques* c 1905–08
Oil on cardboard 29 × 42 cm
(City Art Gallery, Bristol)

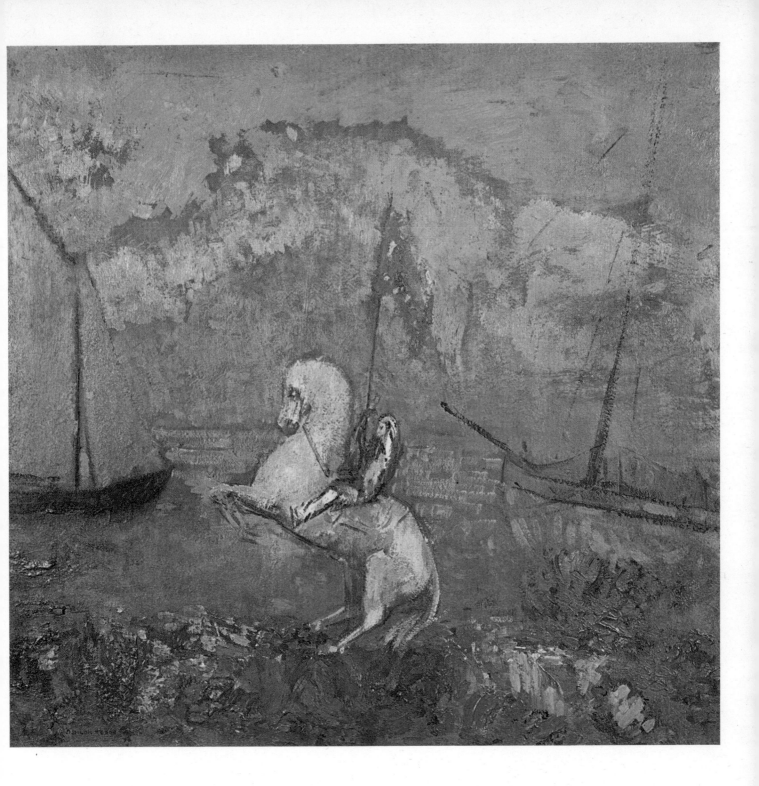

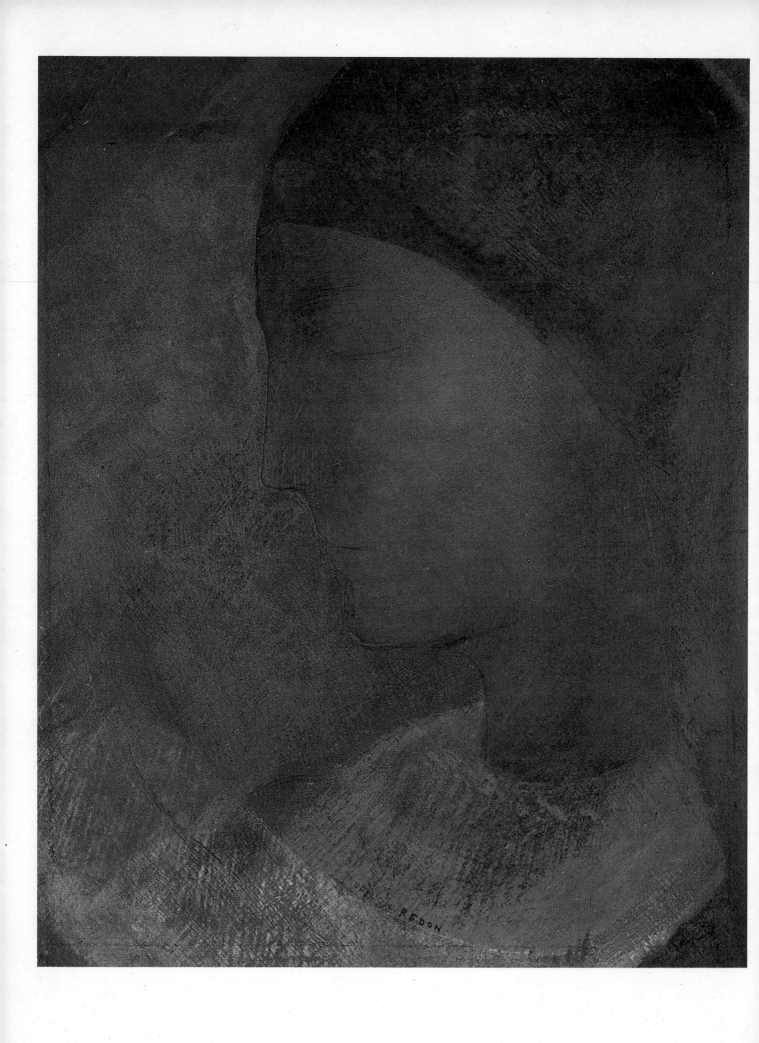

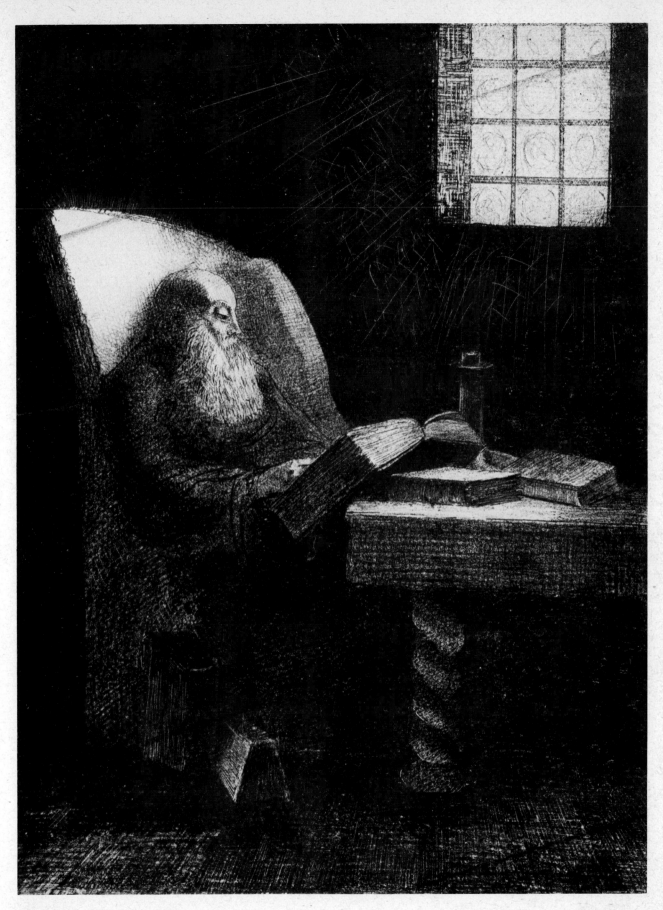

The reader / *Le liseur* 1892
Lithograph 31 × 23.6 cm

Opposite
Blue profile / *Profil bleu*
Pastel 30.2 × 24.7 cm
(British Museum)

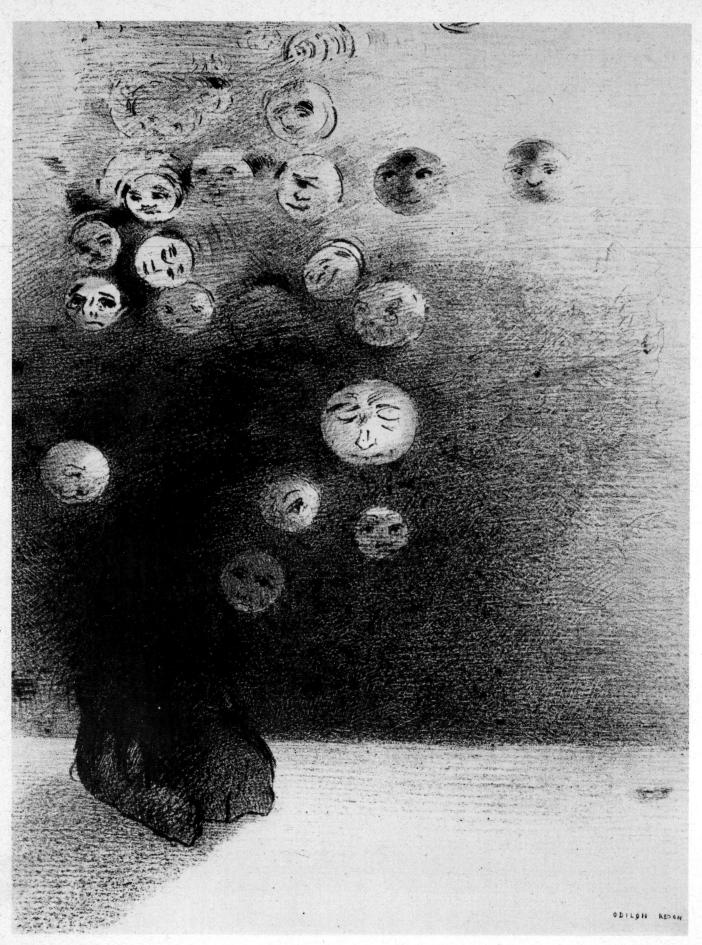

Is there not an invisible world / *N'y a-t-il pas un monde
invisible*, from *Le Juré* 1887
Lithograph 21.8 × 16.9 cm

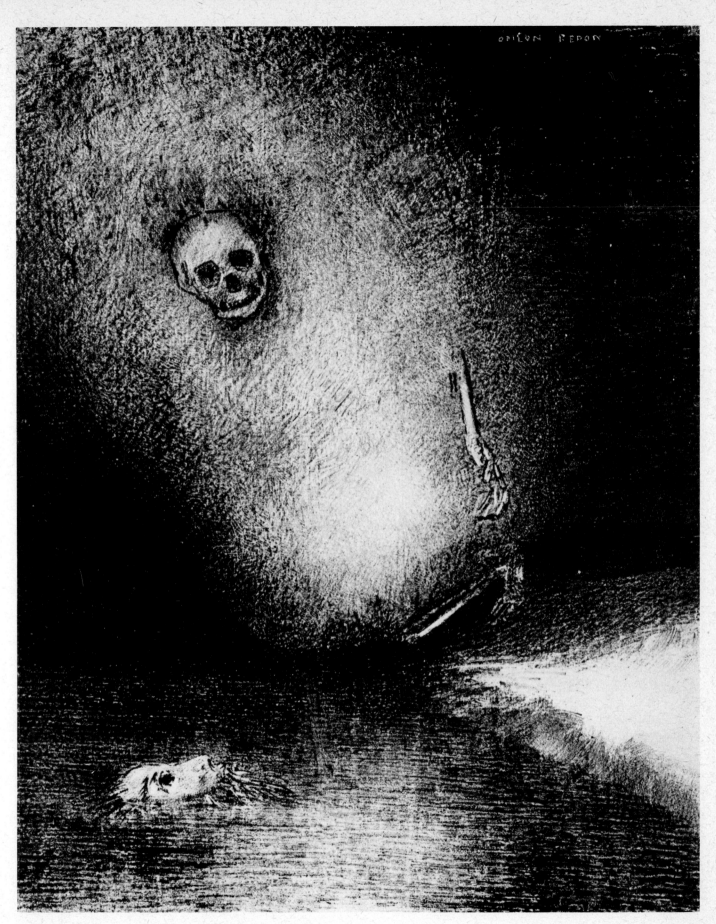

The dream ends in death / *Le rêve s'achève par la mort*,
from *Le Juré* 1887
Lithograph 23.8 × 18.7 cm

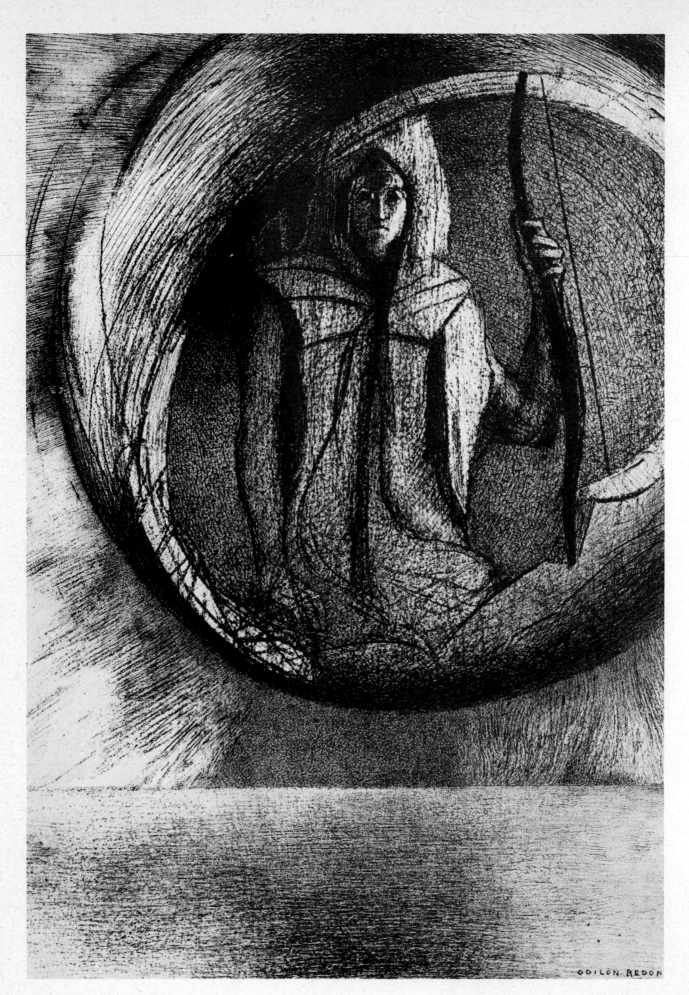

And beyond, the astral idol, the apotheosis / *Et là-bas,
l'idole astrale, l'apothéose*, No. 2 of *Songes* 1891
Lithograph 27.7 × 19.2 cm

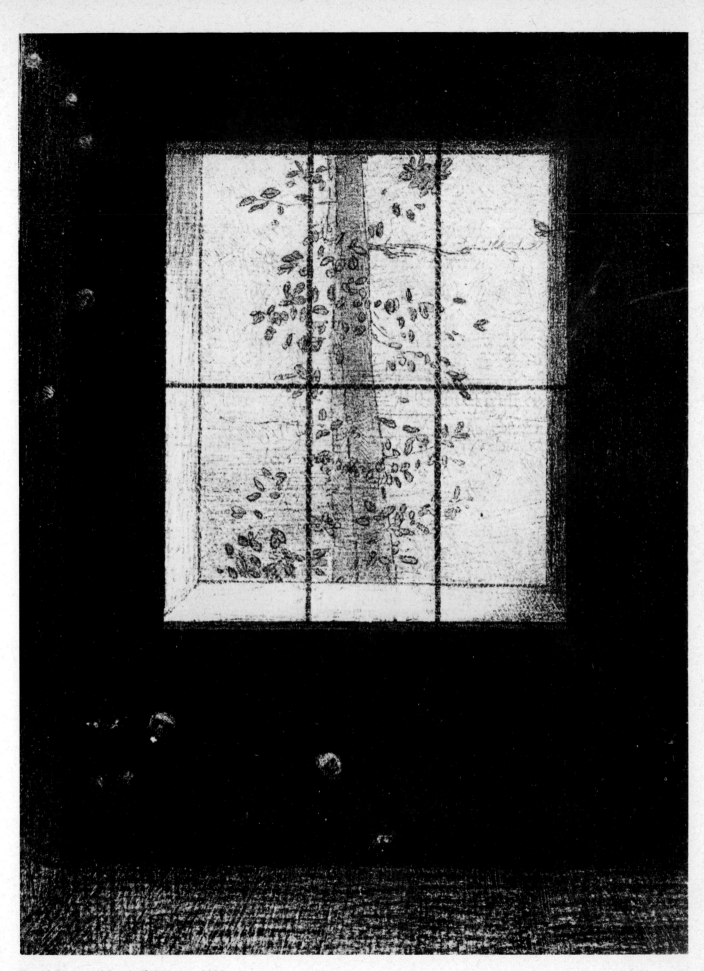

Day / *Le jour*, No. 6 of *Songes* 1891
Lithograph 21 × 15.8 cm

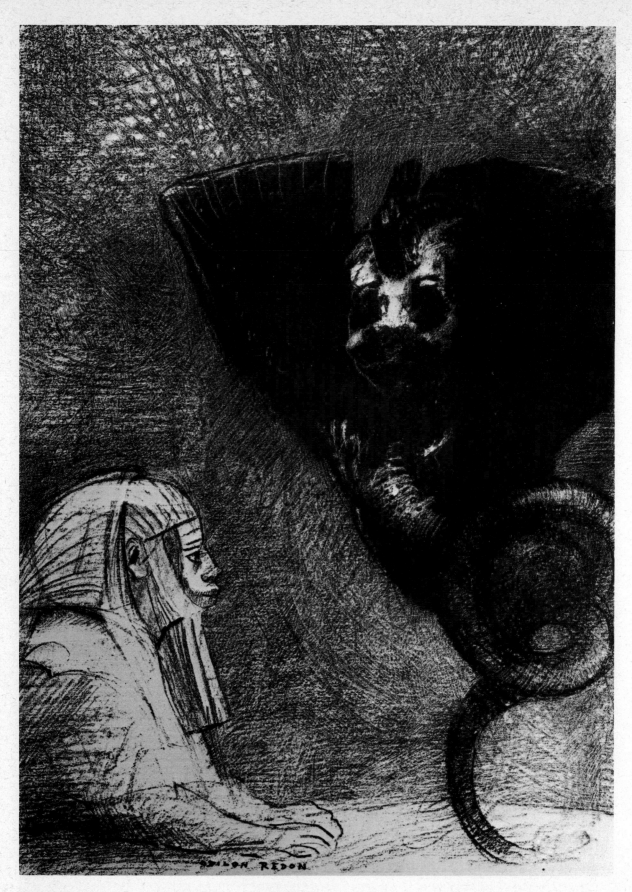

The Sphinx: 'My gaze, which nothing can deflect, passes
through things and remains fixed on an inaccessible
horizon.' The Chimera: 'I myself am light and joyful' / *Le
Sphynx: Mon regard que rien ne peut dévier, demeure
tendu à travers les choses sur un horizon inaccessible. La
Chimère: Moi, je suis légère et joyeuse*, No. 5 of *A
Gustave Flaubert* 1889
Lithograph 28.2×20.2 cm

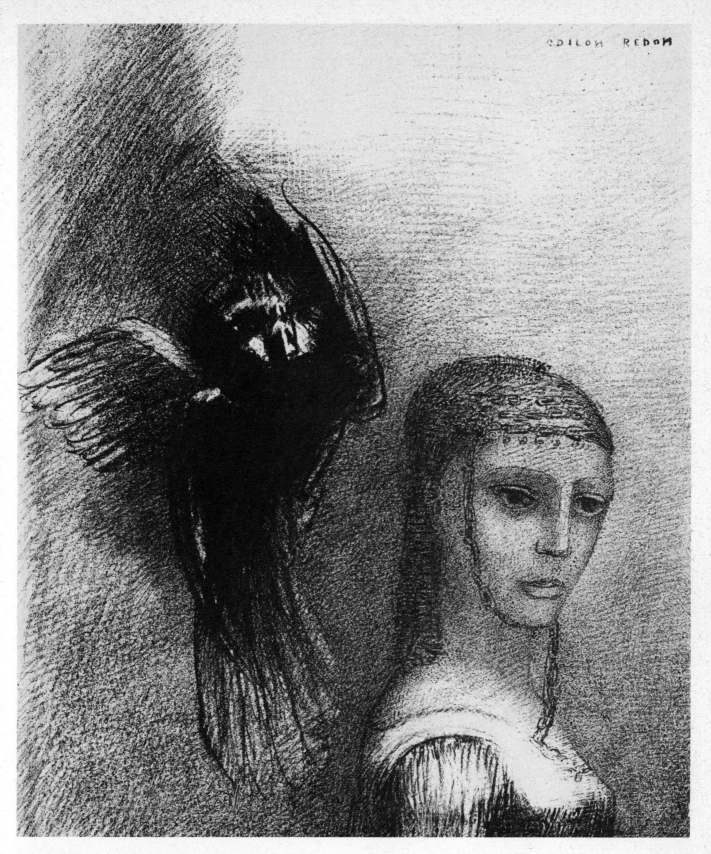

And a huge bird, descending from the sky, hurls itself
against the top of her hair / *Et un grand oiseau qui
descend du ciel vient s'abattre sur le sommet de sa
chevelure*, No. 3 of *La Tentation de Saint-Antoine*, first
series 1888
Lithograph 19 × 16 cm

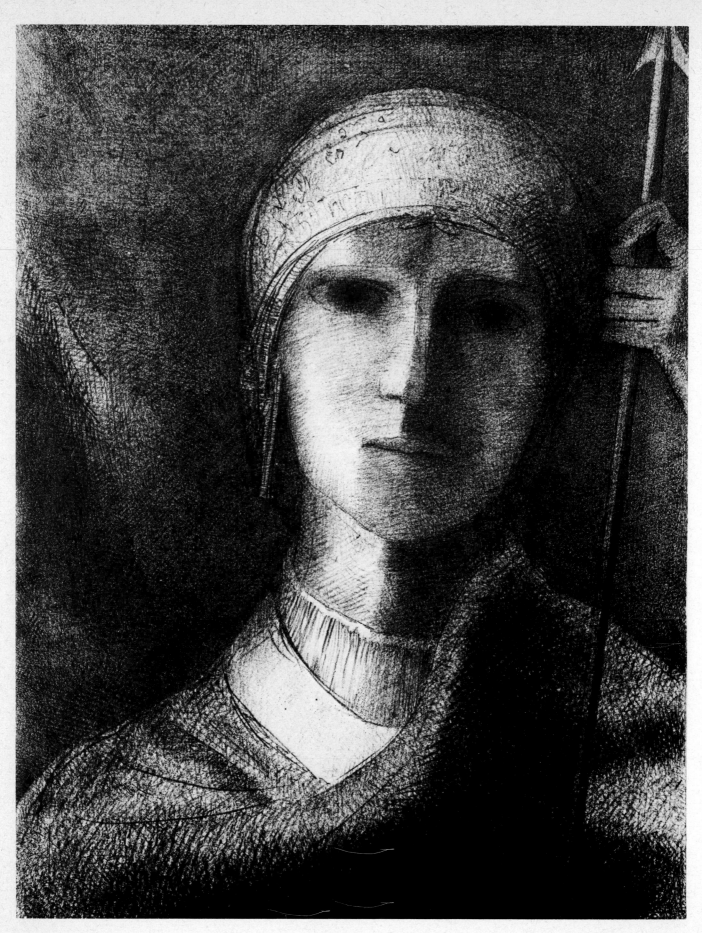

Parsifal 1892
Lithograph 32.2×24.2 cm

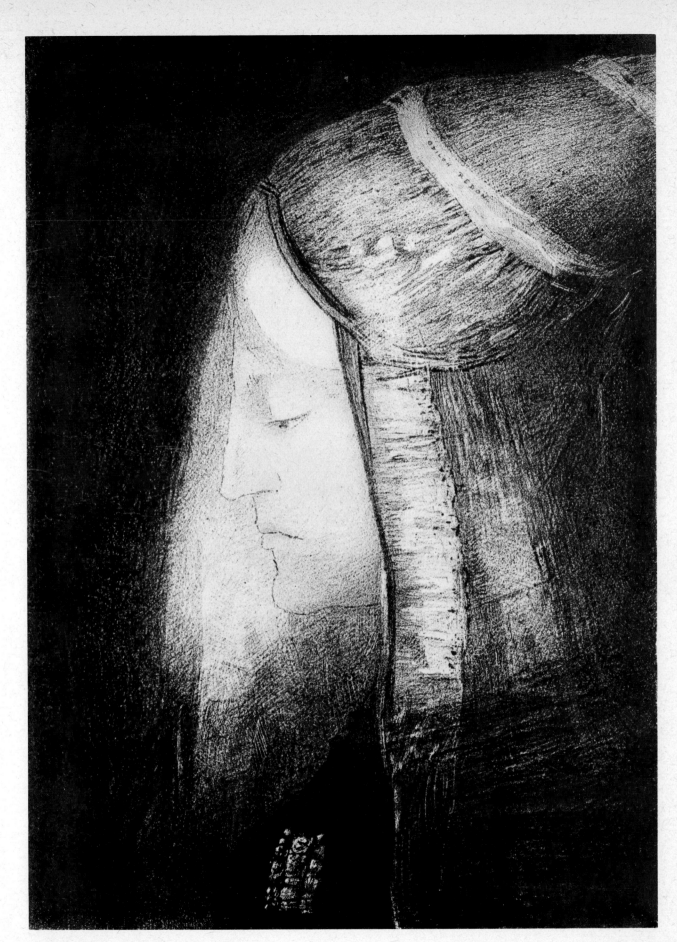

Profile of light / *Profil de lumière* 1886
Lithograph 34×24.2 cm

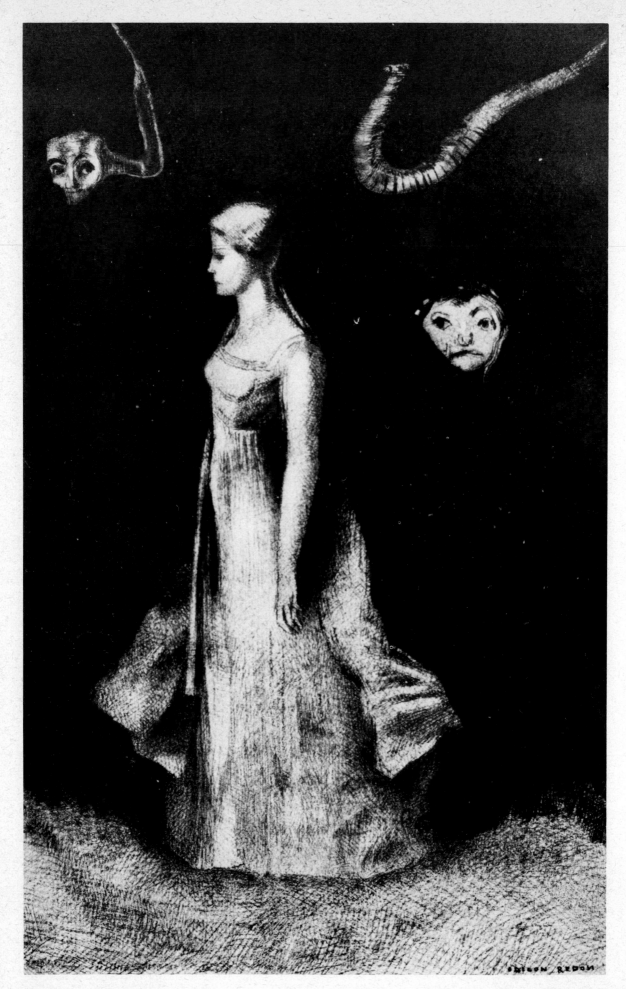

Obsession / *Hantise* 1894
Lithograph 36.1×22.9 cm

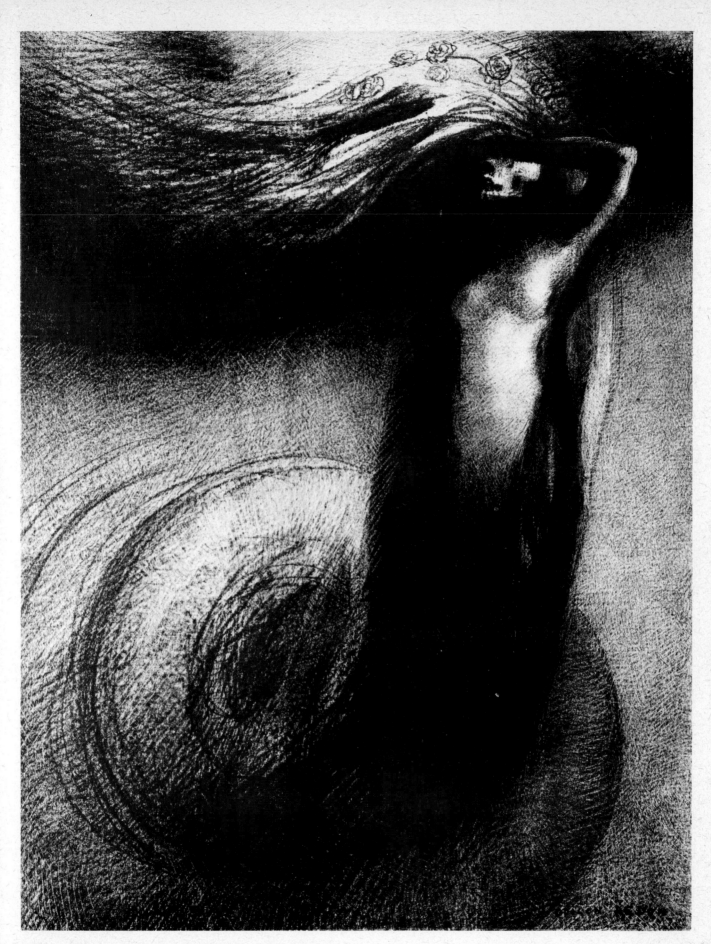

Death: My irony surpasses all others / *La Mort: Mon
ironie dépasse toutes les autres*, No. 3 of *A Gustave
Flaubert* 1889
Lithograph 26.2 × 19.7 cm

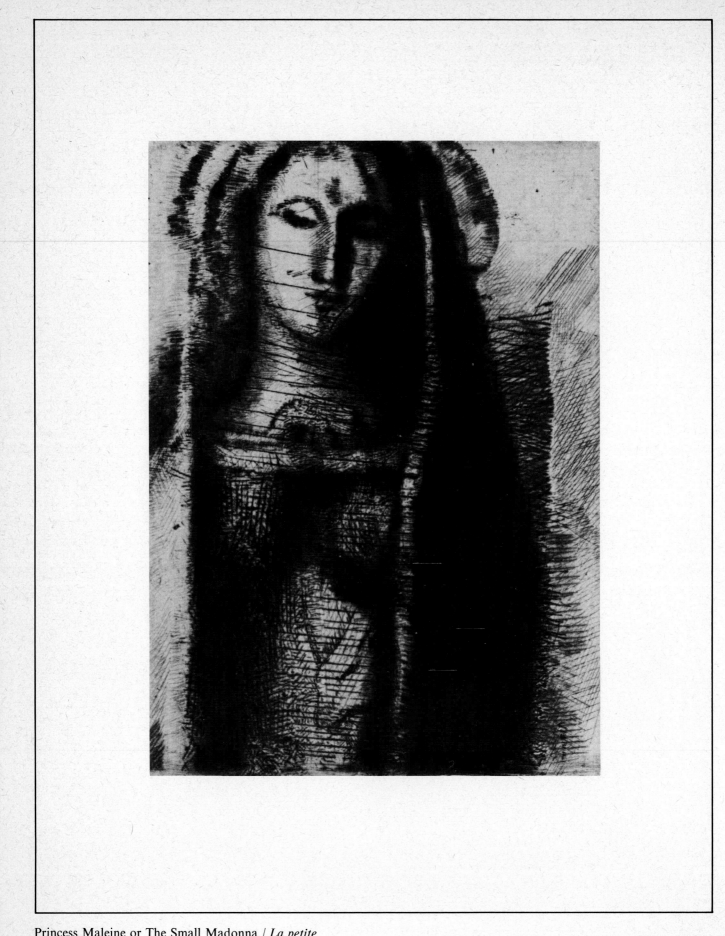

Princess Maleine or The Small Madonna / *La petite*
Madone 1892
Etching 11.9×6.4 cm

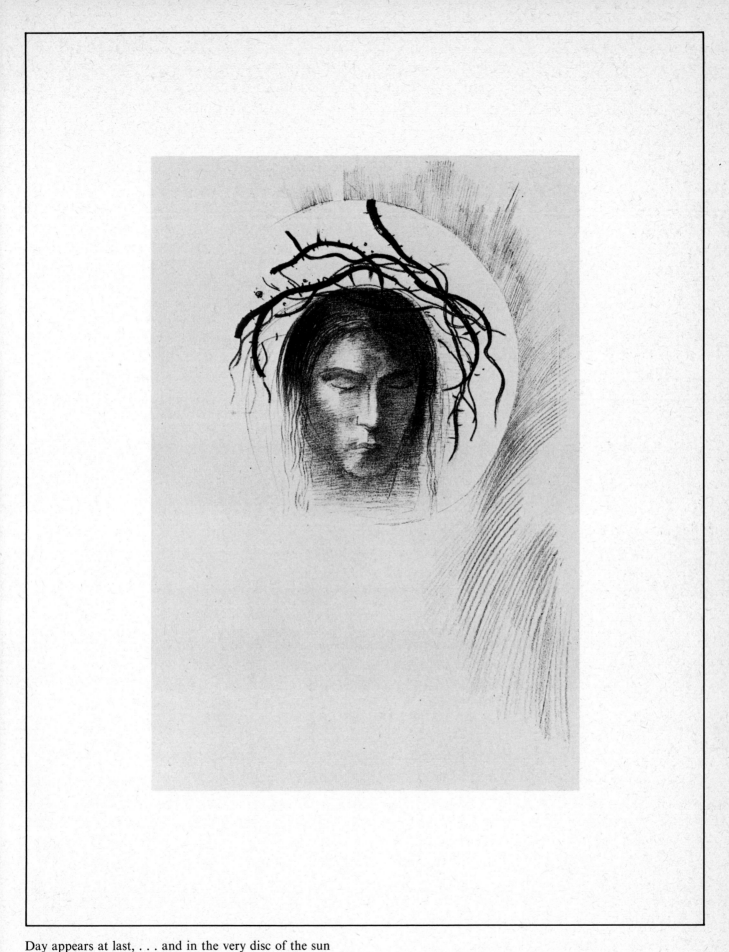

Day appears at last, . . . and in the very disc of the sun
shines the face of Jesus Christ / *Le jour enfin paraît, . . . et
dans le disque même du soleil, rayonne la face de
Jésus-Christ*, No. 24 of *La Tentation de Saint-Antoine* 1896
Lithograph 27 × 26.3 cm

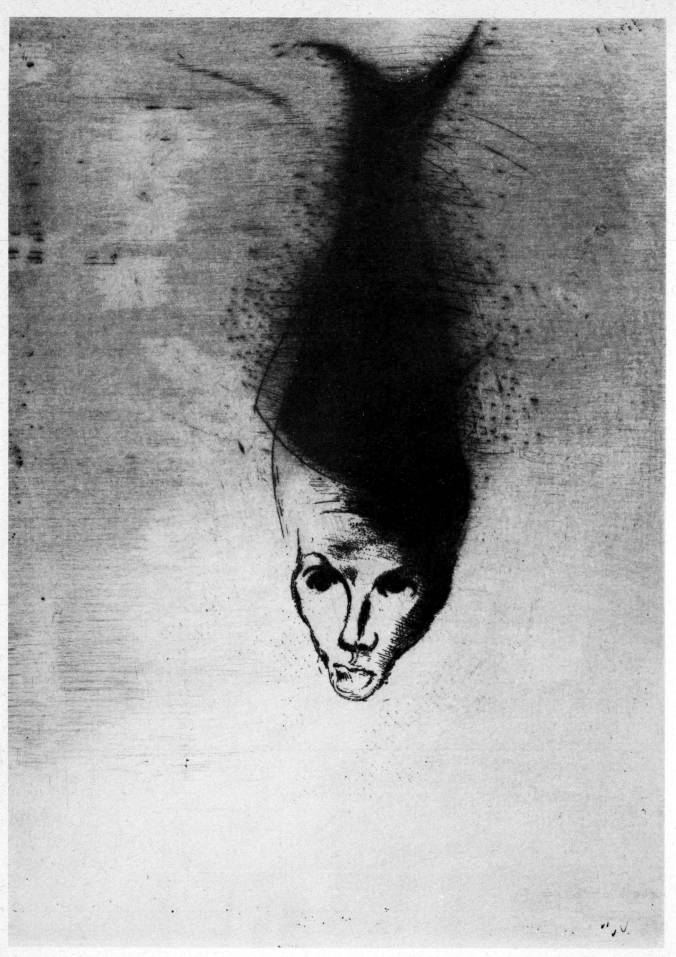

Skiapod / *Sciapode* 1892
Etching 19 × 14 cm

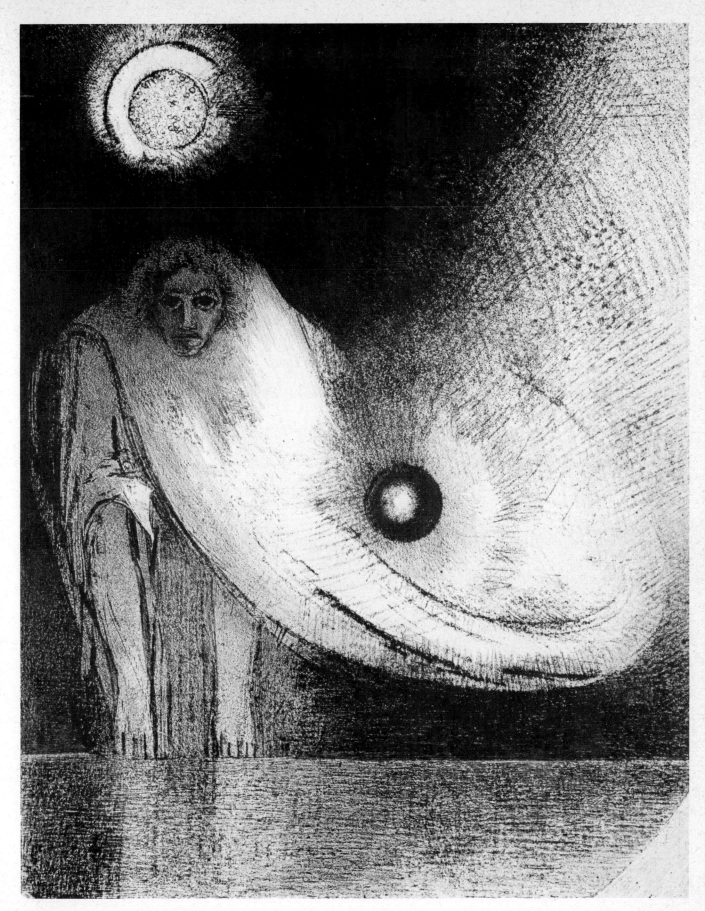

The Buddha / *Le Bouddha* 1895
Lithograph 32.4 × 24.9 cm

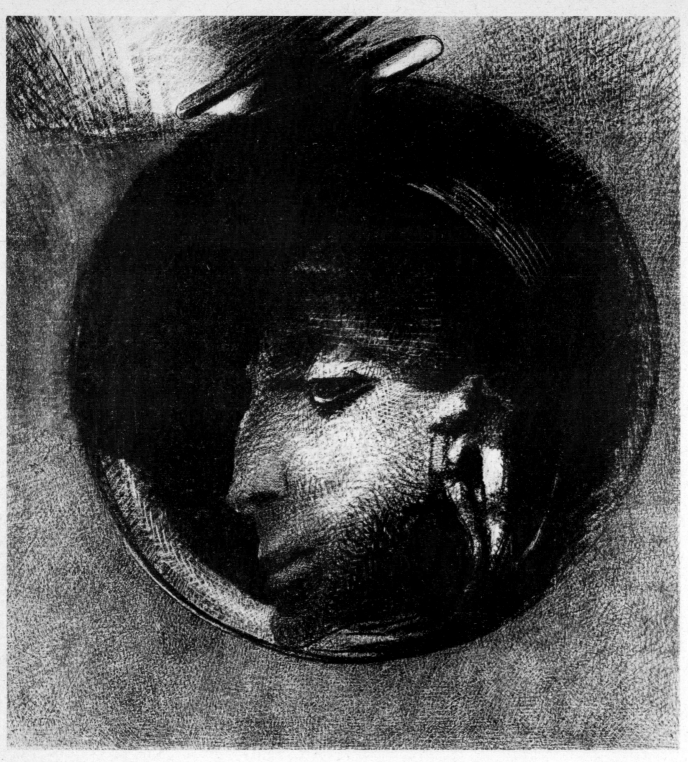

Auricular cell / *Cellule auriculaire* 1894
Lithograph 26.8×25 cm